IMAGES
of America

CHILDREN OF ELLIS ISLAND

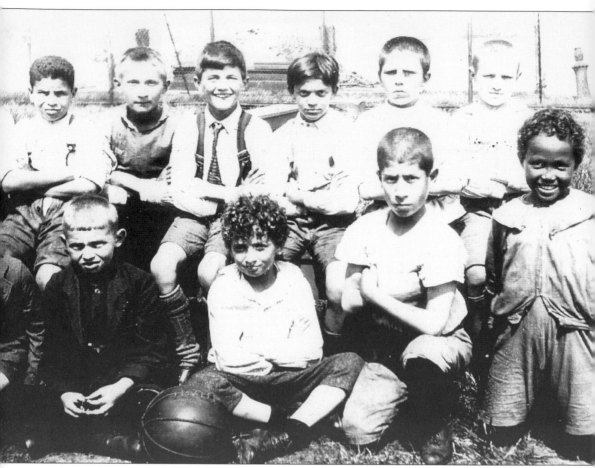

These 11 boys stopped playing so that the American Missionary Association's cameraman Frank L. Moore could take their picture. In spite of coming from different countries and speaking languages and dialects incomprehensible to each other, they were still able to play all sorts of games with little trouble at all. (Frank L. Moore photograph, Amistad Research Center, Tulane University.)

IMAGES
of America

CHILDREN OF
ELLIS ISLAND

Barry Moreno

Copyright © 2005 by Barry Moreno
ISBN 0-7385-3894-9

Published by Arcadia Publishing
Charleston SC, Chicago IL, Portsmouth NH, San Francisco CA

Printed in Great Britain

Library of Congress Catalog Card Number: 2005928463

For all general information contact Arcadia Publishing at:
Telephone 843-853-2070
Fax 843-853-0044
E-mail sales@arcadiapublishing.com
For customer service and orders:
Toll-Free 1-888-313-2665

Visit us on the internet at http://www.arcadiapublishing.com

*This book is dedicated to the many immigrant children
who passed through Ellis Island, especially three who shared
their stories with me: Arthur Tracy, Bob Hope, and Isabel Belarsky.*

ELLIS ISLAND HOLDS BOY OF FIRST CABIN

Mr. and Mrs. W. G. Avery Meet 9-Year-Old Son from England, but He Is Taken from Them.

IMMIGRATION LAW BLAMED

Officials Enforcing the Statute in Hope That Authorities at Washington Will Modify It.

Although his parents met him at the White Star pier yesterday when he arrived from Liverpool on the Baltic, Thorold Avery, 9 years old, had to go to Ellis Island with the immigrants to appear before a Board of Special Inquiry. The boy came over in the first cabin to go to school in this country. On the voyage he was in charge of Mr. and Mrs. John E. Druiff and Dr. Alfred Mosely, the well-known English educator, who assisted Mr. and Mrs. Avery in trying to convince the Immigration Inspector that as the father and mother were at the pier it would be unjust to take their son away from them.

W. G. Avery, the boy's father, is employed by William Baumgarten & Co.,

of 715 Fifth Avenue, dealers in fine furniture. He said he had ample evidence from bankers and other business men to show that he was quite able to prevent his 9-year-old son from becoming a public charge. Mr. Avery is said to be well-to-do.

The Inspector listened patiently and replied that the United States immigration laws demanded that all alien children arriving in this country without their parents or legal guardians must be sent to Ellis Island to go before a Board of Special Inquiry. Thorold Avery and his parents left the Baltic at 3 o'clock on the immigrant barge for Ellis Island.

Officials of the International Mercantile Marine Company said this was the first time in their recollection that an alien under 16 traveling in the first cabin unaccompanied had been sent to Ellis Island when both parents were at the pier to meet the steamer on arrival.

At Ellis Island it was explained that the immigration officials had frequently written to the Department of Labor at Washington pointing out the faults in the present law, in an effort to get it amended to give the Inspectors on the ship some discretionary power.

William Williams, the former Immigration Commissioner at Ellis Island, said when he was in charge of the bureau that the best way to get bad laws amended was to enforce them rigorously, and that policy has been adopted by the officials ever since.

AN ENGLISH BOY AT ELLIS ISLAND. This article tells the story of a nine-year-old boy named Thorold Avery, who traveled to the United States without his parents aboard the SS *Baltic*. In spite of having traveled first class and having been met at the pier by his parents, he was still taken to Ellis Island for questioning. This was one of the many examples of the red tape for which the Bureau of Immigration was notorious. (The *New York Times*, October 23, 1915, 20.)

CONTENTS

ACKNOWLEDGMENTS

I am more than grateful for all the kind assistance I received when researching and writing this book. For suggesting that I write such a volume in the first place, I must thank Andrew Beauchamp at Ellis Island and José Sepulveda at Liberty Island. At Arcadia Publishing, I thank my wonderful and patient editor, Pam O'Neil, and production editor Sarah Gabert. And for her assistance with regard to the Frank L. Moore pictures, many thanks are due to the resourceful Shugana Campbell, archivist of the Amistad Research Center at Tulane University. For sharing her story of immigration, I thank Isabel Belarsky. My fellow workers at Ellis Island were as helpful as always. Of this group, I should particularly like to thank Diana Pardue, George Tselos, Jeffrey Dosik, Janet Levine, Eric Byron, superintendent Cynthia Garrett, Dave McCutcheon, and our library volunteers Valerie Sinclair, John Kiyusu, and Thomas Gregg. I am also grateful to filmmaker Lorie Conway and Ellis Island immigrant Emmie Kremer.

INTRODUCTION

"The sweetest things that grow are children and flowers." So said Ellis Island's head matron Regina Stucklen back in 1904. With the aid of her 11 assistants, she was charged with the care of 200 or so young immigrants who were detained at Ellis Island in the week that her story appeared in the *Washington Post*. She described the great variety of foreign youths with amusement and affection, and introduced the reporter to the choicest of the lot. But she made it perfectly clear that what he was seeing that morning was not in the least bit exceptional: it happened every day. In fact, in every week of the year, the matrons cared for unfortunate children, teenaged girls, and women facing the real possibility of either exclusion or deportation. It was quite a job to handle. But other workers at Ellis Island faced similar tasks, whether inspectors, interpreters, clerks, messengers, or missionaries. Fortunately, Augustus Sherman, the chief clerk of the station, took many pictures, a number of which are included in this book.

From the first day Ellis Island opened, in January 1892, until it closed 62 years later, in November 1954, thousands upon thousands of young people found themselves inmates in America's top federal immigrant control station. There, they waited at the side of parents, guardians, and friends. Some waited alone. For immigrants in the detention rooms, it was especially miserable. For there, they listened with some trepidation when a messenger stepped into the room to call out the names of those to appear before a board of special inquiry or to meet a relative waiting for them in the Discharging Division in the West Wing. Curiously, it is sometimes forgotten that children comprised a major share of the station's fluid population. Yet, like the adults, they too flowed in and out of the island. Some of these young people had traveled with their families; others had come alone, sometimes to join parents or relatives, sometimes to work. Many teenaged boys were part of a throng of migrant laborers; others came as orphans and some as stowaways. But all were excited by the adventure of the sea voyage to America, and when they arrived, the stunning vision of the New World that was presented by the imposing buildings of Manhattan.

At Ellis Island, children were defined by their age and treated differently based upon their gender. For many years, any youngster below the age of 16 was regarded as inadmissible without a parent or guardian. This regulation was only really significant in regard to boys, since girls and women were always required to have a proper male escort to enter the country. But boys 16 and older and all men were generally admissible on their own account. The unfairness of this policy was upheld on grounds that females needed special safeguards to protect them from the dangers of immorality and white slavery. These threats were real, and stories of "fallen immigrant girls and women," widely publicized by religious leaders and social workers, alarmed the public.

Why did boys come to America? They came for the very same reason that men did: to seek employment and to earn higher wages than they could in their homeland. The emigration of teenaged boys was an enormous reality. Italians and Greeks were often brought to America by bosses called *padrones*. These men brought the boys over as cheap laborers and found jobs for them in factories, mills, and outdoor labor projects such as were available at construction sites. On the other hand, northern Europeans often came to work as farm laborers. Another reason some emigrated was simply to earn enough money so that their sisters would have a dowry with which to marry. Young Greeks were especially affected by this social duty. Meanwhile, other teenagers came to escape military service, especially during time of war. Thus, the Russo-Japanese War, the Balkan Wars, and both world wars were responsible for quite a number of youthful exoduses. But wartime was not the only time young men avoided the draft. They also left simply to avoid the onerous requirements of military service imposed on soldiers in Europe. This was especially true of the nations in Eastern Europe and the Ottoman Empire.

Girls came to America for rather different reasons. Aside from simply joining relatives, girls often came to get married. Girls married in their teens in those days, and many were already betrothed and came simply to join their fiancés. Others came as "picture brides," young women and teenaged girls who had been sent steamship tickets by strangers in an arranged marriage. Some teenage boys and girls came to the United States for educational or vocational purposes. Entering as students, they were bound for schools, colleges, seminaries, or convents.

Another set of young immigrants were those with personal or family problems. Of this number, some had experienced misfortunes and many were orphans. The arrangement to bring over orphans was usually made by charity workers, missionaries, and immigrant aid societies. Thousands passed through the station, having been admitted under bond—bonds were usually obtained by sponsors such as the charitable groups mentioned. After leaving Ellis Island, many were put on orphan trains that took them to farms and small towns throughout the country. One such orphan was Harry Gerguson, who later masqueraded as "Prince Michael Romanoff" and ended up as a successful restaurateur in Hollywood.

Another group of youngsters traveling on their own were adventurers or those who were lost. Whether caused by wanderlust, willfulness, or delinquency, many such youngsters found themselves detained at Ellis Island. Some won the support of immigrant aid workers and were admitted, while some of the boys were able to convince inspectors that they could fend for themselves and were old enough to carry on. But others were not so persuasive and found themselves in an area of the Main Building known as the Deporting Division. The pages of this book contain a number of such unfortunate cases.

It is clear from this overview that most immigrant children had little trouble in passing through Ellis Island, and many of them stayed in the United States for good. Of these, the greater number of them grew up to become hard workers, parents, taxpayers, and good neighbors. Many became American citizens and served their country in war and peace. A certain few entered walks of life that led to worldly renown. Counted among this relatively small group were Supreme Court justice Felix Frankfurter, Los Angeles cardinal archbishop Timothy Manning, musician Xavier Cugat, songwriters Irving Berlin and Jule Styne, bodybuilder Charles Atlas, wrestler John "the Golden Greek" Londos, Hollywood film stars Claudette Colbert and Bob Hope, singers Arthur Tracy and Alfred Piccaver, dancer Pearl Primus, novelists Ludwig Bemelmans (author of the Madeline stories) and Isaac Asimov, and the Trapp Family Singers. These and others contributed richly to American society and, through their special gifts, touched millions of people.

—Barry Moreno
Staten Island, August 2005

One

DOWN TO THE SEA
IN STEERAGE

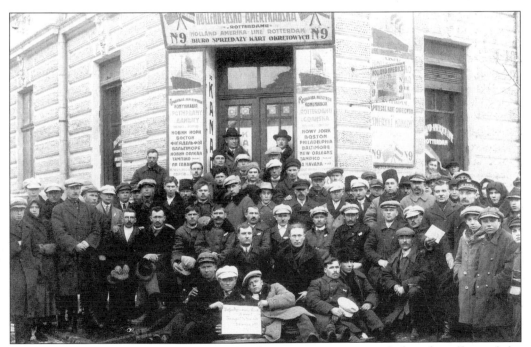

BULGARIANS FOR AMERICA. A group of Bulgarian emigrants pose before the offices of the Holland-America Steamship Line in Tarnopol, Bulgaria. This company's agents sold tickets for ships sailing not only to U.S. cities like New York and New Orleans but also to Tampico, Mexico, and Havana, Cuba. These passengers, who include children as well as men and women, are probably emigrating for economic betterment. From here, all of them had to travel by train to the Dutch port of Rotterdam to reach their steamships. (Holland-America Line Archives.)

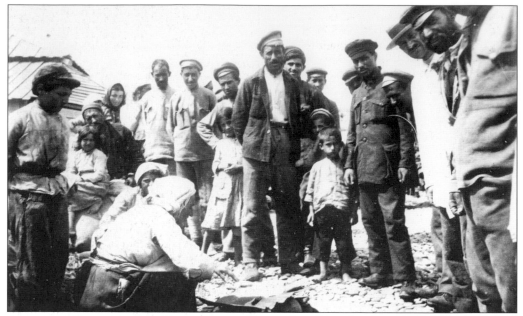

ARMENIAN REFUGEES ON A BEACH BY THE BLACK SEA. Not all emigrants left their homeland to escape poverty; some left to avoid violence and war. One such group was the Armenians. In this 1920 picture, a crowd of them stands in misery upon a beach at Novorossiysk, Russia. There, the Armenians awaited deportation to their benighted homeland. These refugees had survived the dreadful massacres of Armenians in Ottoman Turkey during World War I. (G. P. Floyd photograph, American Red Cross.)

ENTICEMENTS TO EMIGRATE. Just like the airlines of today, early steamship companies enticed people to travel abroad at discount prices. From 1845 to 1930, most travelers were emigrants, so Britain's White Star Line vied with its many rivals to offer cheap steerage tickets to America. This advertisement was primarily intended for Irish emigrants. (National Park Service.)

LEWIS KRAUSS, BOY EMIGRANT. Lewis Krauss is pictured in Russia around 1908 at age 15. The young Jewish emigrant is just about to set off for America. He joined thousands of other immigrant boys who passed through Ellis Island on their own. Many Jews fled from the violent anti-Semitic pogroms of the period. Lewis became an American citizen in June 1916. (National Park Service.)

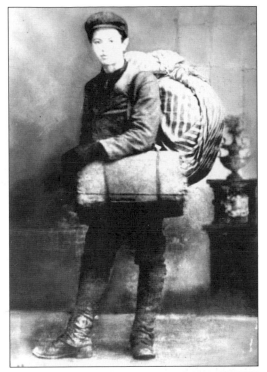

AT THE BREMEN RAILWAY TERMINUS. A crowd of new-arrived emigrants is seen standing in front of the railway station in Bremen, Germany. From here, the emigrants traveled to the nearby port of Bremerhaven to a North German Lloyd Line steamer sailing for America. Germans, Poles, Jews, Hungarians, Slovaks, Romanians, and Lithuanians were among the many emigrant nationalities selecting Bremerhaven as their way of exiting Europe. (Staatsarchiv Bremen, Germany.)

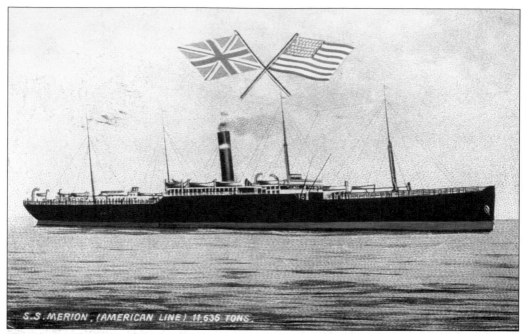

THE STEAMSHIP MERION. The SS *Merion* was a typical medium-sized transatlantic vessel upon which emigrants traveled to America. Built in Scotland in 1902, it carried 1,700 third-class and 150 second-class passengers. The *Merion* was owned by the American Steamship Line, an Anglo-American firm. During World War I, it served as a battleship for Britain's Royal Navy. It was sunk in the Aegean Sea by German forces in 1915. (National Park Service.)

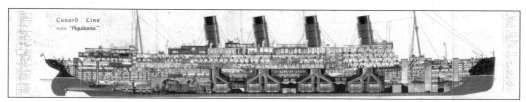

THE ROYAL MAIL STEAMSHIP AQUITANIA. In contrast to the *Merion*, the RMS *Aquitania* was enormous. With four funnels, it could hold 2,052 in third class, 614 in second, and 597 in first. Although the mighty vessel weighed 45,647 tons, its impressive fourth funnel was merely a dummy. Built in Scotland, the ship made its maiden voyage to New York in 1914. The Cunard Line lent the *Aquitania* to His Majesty's Navy during both world wars. It was broken up for scrap in 1950. (National Park Service.)

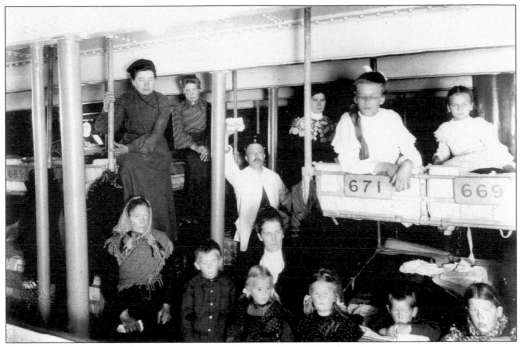

IN THIRD CLASS ABOARD THE *HELLIG OLAV*, 1904. Scandinavian emigrants are seen in a third-class cabin aboard the SS *Hellig Olav* (St. Olaf). The ship was built in Scotland for the Scandinavian-American Line, with headquarters in Denmark. From 1902 to 1931, it sailed regularly from its home port of Copenhagen to Oslo and thence to New York and then back again. It held 900 third-class, 140 second-class, and 130 first-class passengers. (Norske Folkemuseum.)

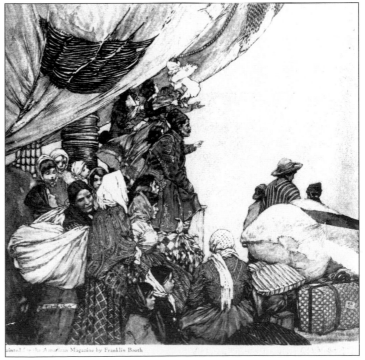

ON THE DECK OF AN OCEAN STEAMER. This painting by Frederick Booth suggests the very certainty of dreariness, vexation, and excited expectation promised to those who ventured beyond European seas. The artist offers a sympathetic treatment by emphasizing mothers and children on a steerage deck. (National Park Service.)

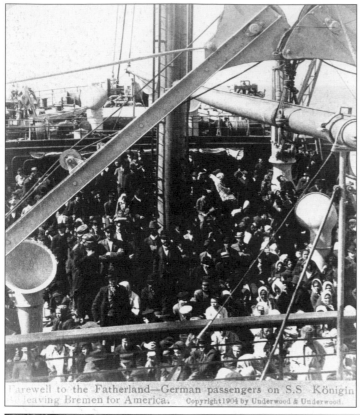

FAREWELL TO THE FATHERLAND. In 1904, emigrants crowded upon the steerage deck of the SS *Königin Luise* (Queen Louise) at Bremerhaven. The ship had been constructed in Stettin, Germany, in 1896. After years voyaging between Bremerhaven and New York and to Australia ports, it was reassigned to the Mediterranean-to-New York trade. Later owners of the vessel changed its name to the *Omar* (1920) and then the *Edison* (1924). At long last, the majestic ship, which had once ruled the waves as the *Königin Luise*, was sold to Italian scrap dealers in 1935. (National Park Service.)

Farewell to the Fatherland—German passengers on S.S. Königin leaving Bremen for America. Copyright 1904 by Underwood & Underwood.

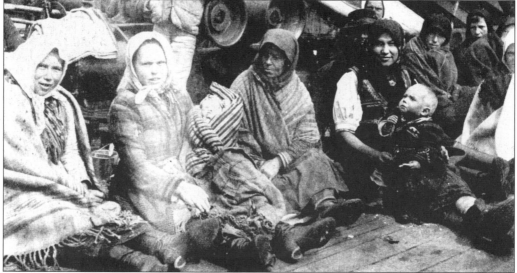

WOMEN OF STEERAGE. Emigrant mothers with their little ones show a sense of their willingness to endure hardship in their resolve to come to the New World. The picture was taken on a steerage deck. Steerage was the cheapest accommodation available to travelers and attracted millions of emigrants. However, the inferior conditions it offered gave it a bad reputation. To get around this, several steamship lines changed the name steerage to "third class." (Library of Congress.)

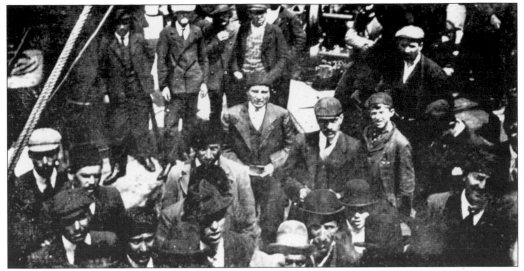

MEN OF STEERAGE. Crossing the vast ocean was a tedious affair. One grew weary and grimy, and inevitably, unpleasant smells drifted about and attached themselves to one's clothing. The odor down below in steerage forced most passengers to seek the fresh, salty air of the steerage deck above. For hours at a time, passengers lounged about in the open air. This scene shows the great number of men who emigrated in search of work in America. Italians, Greeks, Portuguese, and Slavs were typical of this emigration. (Author's collection.)

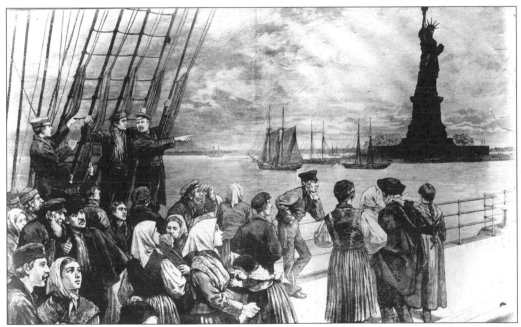

WELCOME TO THE LAND OF FREEDOM. This 1887 drawing shows the steerage deck of an ocean steamer passing by the Statue of Liberty, which had only been unveiled in the previous October. In those days, foreigners were taken to the Castle Garden Immigrant Depot for inspection. Castle Garden received millions of immigrants, notably Germans, Irish, British, and Scandinavians. The immigrant depot operated from 1855 to 1890. Castle Garden immigration records are now available on the Internet. (*Frank Leslie's Illustrated Newspaper*, July 2, 1887.)

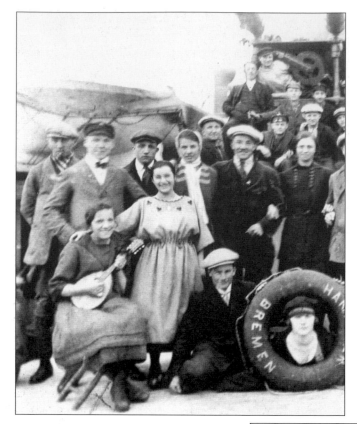

EMIGRANTS CELEBRATING THEIR ARRIVAL IN NEW YORK HARBOR. Playing her mandolin, German emigrant Anna Grossmann Krause joins family members and fellow passengers to celebrate the ship's entrance into New York Harbor. This picture was taken aboard the SS *Bremen* in March 1923. The steamer had two funnels and two masts. It was built in Germany in 1900. (National Park Service.)

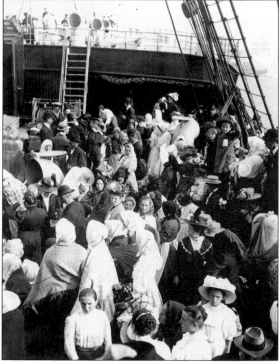

ARRIVAL IN "THE LAND OF HONEY." The steerage deck's passengers eagerly await their arrival and landing in America, which some immigrants called "the land of honey." Their optimism about American prosperity seemed to know no bounds, for many even believed in the legend that America's streets were paved with gold. This picture was taken in New York Harbor in 1920. (Boston Public Library.)

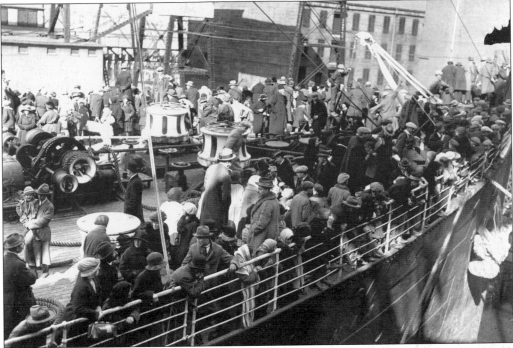

THE CARMANIA DOCKS. With excitement, immigrants—many wearing fresh garments—disembark at a pier in Manhattan. A steamer of England's Cunard Line, the *Carmania* was the first of the company's ships to be fitted with turbine engines. This made it sail faster than many of its rivals. Built in 1905, it held 1,100 third-class, 350 second-class, and 300 first-class passengers. It was sold to ship breakers in November 1932. (Boston Public Library.)

A GRAND VESSEL PASSING BY. This is how such grand steamers looked from the New York or New Jersey shore when they passed into New York Harbor. This ship's three funnels are a sure sign of its grandeur. This picture might have been taken on Staten Island or Brooklyn. (National Park Service.)

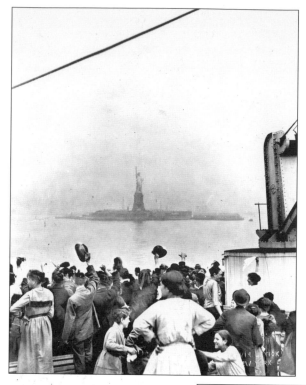

SALUTING LIBERTY. With their hats in the air, immigrants noisily cheer their arrival in America by saluting the Statue of Liberty. This photograph was taken aboard the White Star Line's magnificent steamer *Olympic.* Constructed in Ireland for the British firm in 1911, the *Olympic* was the sister ship to the doomed *Titanic,* which sank in April 1912. The *Olympic* held 1,020 third-class, 510 second-class, and 1,054 first-class passengers. It was retired from service in March 1935. (Mariners' Museum, Newport News, Virginia.)

THE STATUE OF LIBERTY. The great sculpture *Liberty Enlightening the World* is pictured in 1890, four years after being unveiled. Representing ancient Rome's goddess of liberty, the monument was created by two Frenchmen, scholar Edouard de Laboulaye (1811–1883) and the noted sculptor Frédéric-Auguste Bartholdi (1834–1904). It was completed in 1886. (S. R. Stoddard photograph, Library of Congress.)

Two

IMMIGRANT INSPECTION

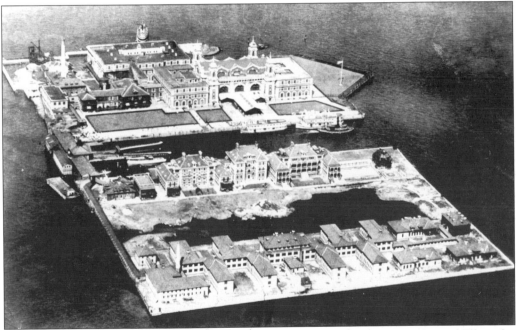

ELLIS ISLAND FROM THE AIR. Ellis Island took its name from an early owner, Samuel Ellis, who died in 1794. The federal government gained control of the property in 1808. The government built Fort Gibson there, and eventually the navy used it for storing ammunition. In 1890, Congress and Pres. Benjamin Harrison selected the island as the site of the federal government's first immigrant control station. But the place was too small, and the government was obliged to enlarge its 3.5 acres to its current size of 27.5 acres. When this aerial picture was taken in 1921, the island measured about 20.25 acres. (National Park Service.)

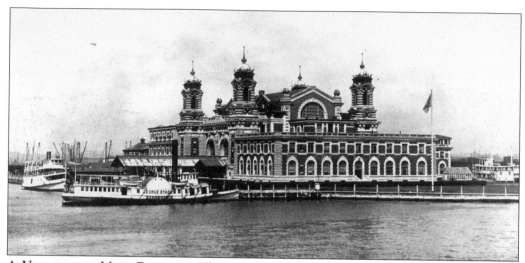

A VIEW OF THE MAIN BUILDING. This scene shows immigrant ferries docked in front of Ellis Island's magnificent Main Building in 1905. The great steamships docked at Manhattan or Hoboken piers, and immigrant passengers were transported to Ellis Island for inspection by small ferryboats and barges. This process went on all day long. Designed by New York architects William Boring and Edward Tilton in 1897, the elegant Main Building was constructed in the years 1898 through 1900. This new brick-and-limestone structure replaced Ellis Island's original wooden immigration buildings, which had burned to the ground in a frightful fire in June 1897. (National Park Service.)

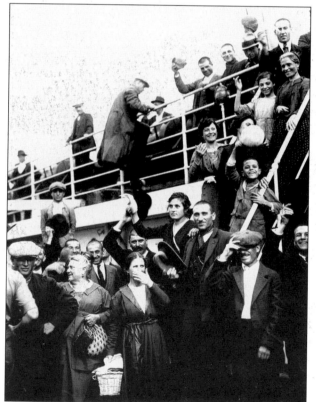

THE FERRY TO ELLIS ISLAND. This picture was taken in 1922 aboard of one of the many small ferryboats that transported hundreds of immigrants from the great steamships to Ellis Island. The steamships were too big to dock at Ellis Island, so they docked at their berths in Manhattan, Hoboken (New Jersey), or Brooklyn. (The *New York Daily News.*)

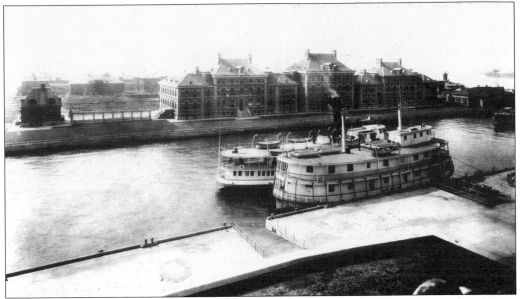

IN THE FERRY SLIP. Along with the docked ferryboats, this *c.* 1914 photograph offers a nice view of some of the hospital buildings that are across the ferry slip from the Main Building. The structures include the general hospital buildings and the Surgeon's House (far left), which was later renamed the Nurse's Cottage. (National Park Service.)

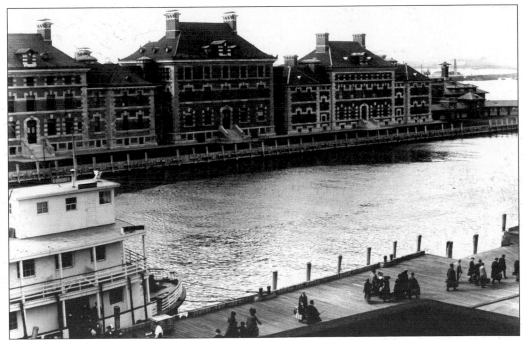

ALONG THE FERRY SLIP'S DOCK. Loaded down with their luggage, foreigners amble along the wooden quay at Ellis Island to a place where they can await inspection. On the opposite side of the ferry slip are the hospital buildings. From left to right in this *c.* 1910 picture are the hospital extension, the hospital administration building, the general hospital building, and the laundry and linen exchange. (National Park Service.)

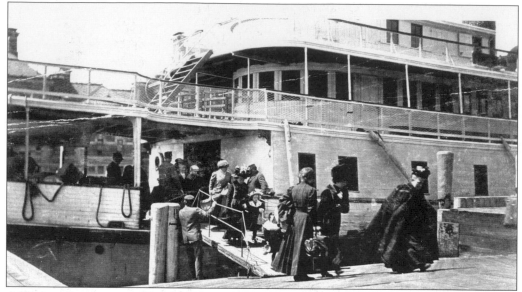

A VIEW OF IMMIGRANTS DISEMBARKING AT ELLIS ISLAND. The year of this picture is unknown, but the style of dress and the building behind the ferry suggests the years 1902 through 1919. The small number of immigrants seen in the picture may even suggest a narrower span of years: the 1914–1919 period. During those years, World War I greatly reduced the number of emigrants who could leave for America, as several of the belligerent powers had blocked emigration and attacked each other's ships, thereby preventing many would-be emigrants from going to America. (National Archives.)

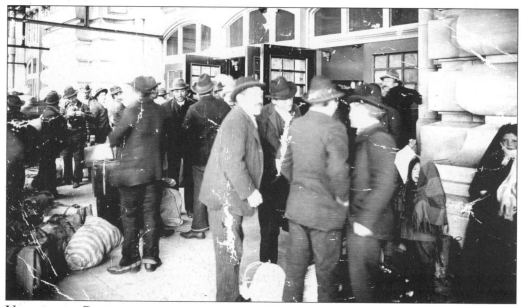

UNDER THE CANOPY AND INTO THE MAIN BUILDING. Shown is a crowd of immigrants burdened with luggage and waiting to enter the Main Building. This group seems to consist chiefly of people from the Mediterranean. Immigrants from that region included Italians, Greeks, Southern Slavs, Armenians, Spaniards, Albanians, Arabs, Turks, and Maltese. (Carpenter Center, Harvard University.)

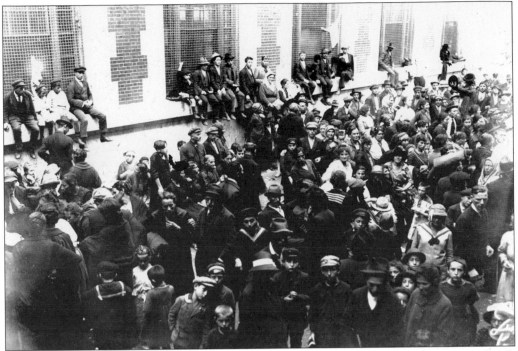

CHILDREN IN THE CROWD. At different times, the legendary station was terribly congested with newly arrived immigrants. Pictured are quite a number of children dispersed in this great crowd of aliens awaiting inspection. The government officially calls a person from a foreign country an "alien"; the term comes from the Latin word for "stranger." This picture was probably taken at the close of World War I, around 1919. (UPI/Bettman.)

OCULAR EXAMINATIONS. The contagious eye disease trachoma caused quite a scare in the United States and in other countries around the world. In this country, the disease was often thought to be associated with European, Asian, and Latin American immigrants. Because of this fear, Ellis Island physicians carefully examined arriving aliens for this disease. Trachoma still troubles humanity. Just as in the past, it often strikes the children of poverty. Nowadays it is commonly found in the countries of Africa and Asia. (National Park Service.)

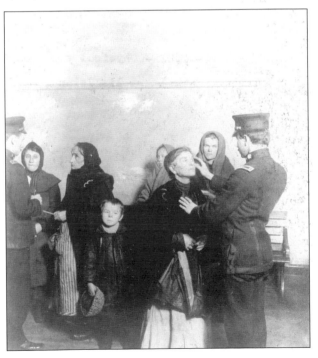

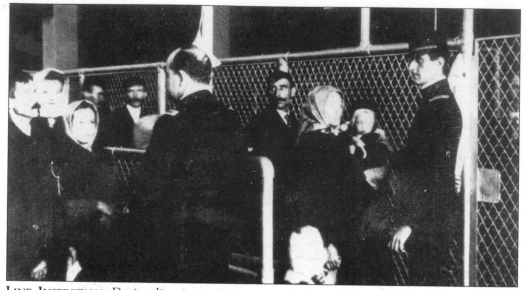

LINE INSPECTION. During line inspection, every immigrant underwent a very brief medical examination. Doctors looked for signs of diseases, such as diphtheria, measles, or tuberculosis. Anyone suspected of sickness was removed from the line and taken to one of the medical examination rooms. Pictured are two Ellis Island physicians, Dr. William O. Wetmore and Dr. Herbert M. Manning, around 1910. The medical staff worked for the U.S. Public Health Service. (National Park Service.)

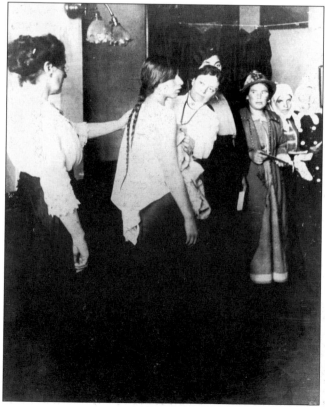

AN IMMIGRANT GIRL'S EXAMINATION. A woman physician examines this immigrant girl in one of the physical examination rooms of the Main Building. Doctors searched for signs of a contagious disease, sickness, and, when appropriate, pregnancy. Such examinations delayed immigrants from leaving Ellis Island as soon as they might wish to and were also a trifle unnerving, especially for those who could speak no English. (National Park Service.)

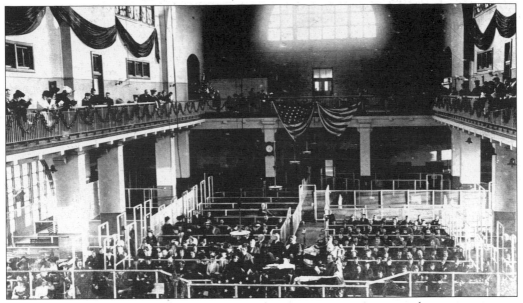

THE REGISTRY ROOM, OR GREAT HALL. Into this majestic room, every single immigrant went to be interrogated by officials of the U.S. Bureau of Immigration. The officials consisted of an inspector, a clerk, and, usually, a foreign language interpreter. There were as many as 14 to 20 lines of immigrants. An inspector asked an immigrant from 29 to 33 or so questions based on the steamship passenger lists. He had the power to accept an immigrant and release him or to detain him for special inquiry. The above photograph was taken around 1907, and the one below was taken around 1912. To handle differing immigration conditions over the years, the room underwent several rearrangements. (National Park Service.)

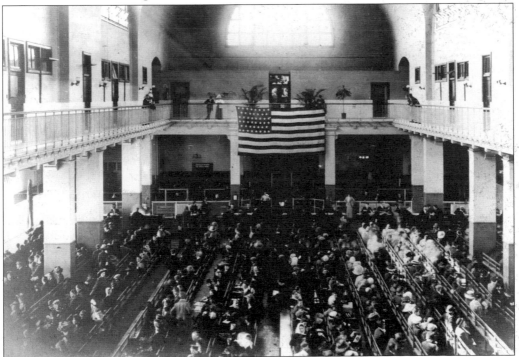

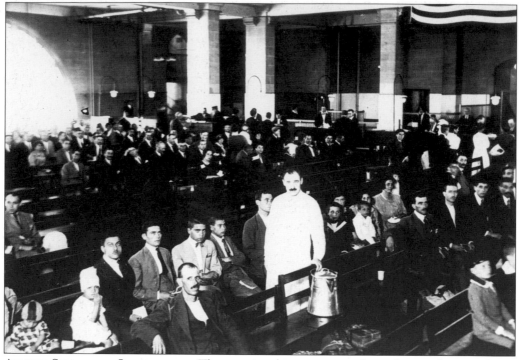

AT THE SERVICE OF IMMIGRANTS. The man in white is an attendant whose task was to bring refreshments to immigrants. He has a milk can with him. Children were typically served milk and sweet biscuits (cookies). This picture appears to date from the 1920s. (National Archives.)

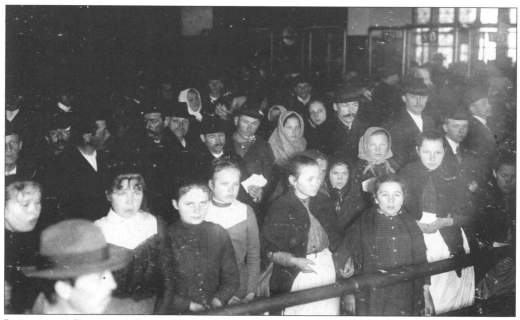

IMMIGRANT GIRLS AND OTHERS IN THE REGISTRY ROOM. This picture focuses on immigrant girls. Behind the girls are young men, many of them sporting moustaches, so common in those far-off days. The picture probably dates from 1910 or earlier. (Carpenter Center, Harvard University.)

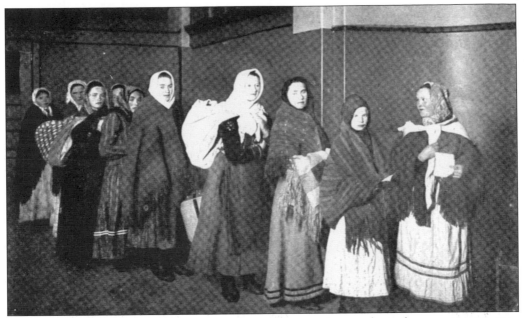

IMMIGRANT WOMEN IN THE INSPECTION LINE. The growing numbers of women immigrating to the United States after 1900 was a phenomenon that aroused interest, since men had long dominated the immigration statistics. This view dates from 1905. Young children, accompanying their mothers, also participated in this change in immigration. The fathers, who usually came to the New World first, would save up part of their meager earnings in order to send their wives and children steamship tickets to America. (Lewis Hine photograph, author's collection.)

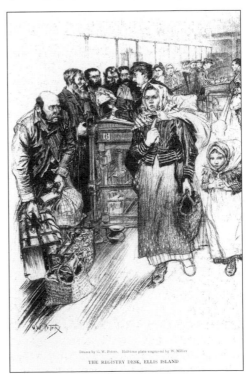

SKETCH OF AN IMMIGRANT WOMAN AND A GIRL. Artist G. W. Peters made this telling sketch focusing on two female immigrants. Again, the rise of women and girl immigrants aroused public interest and sympathy. Efforts to assist them were made by missionaries at the station sent by the Methodist Church, the Roman Catholic Church, the Women's Christian Temperance Union, and the National Council of Jewish Women. (National Park Service.)

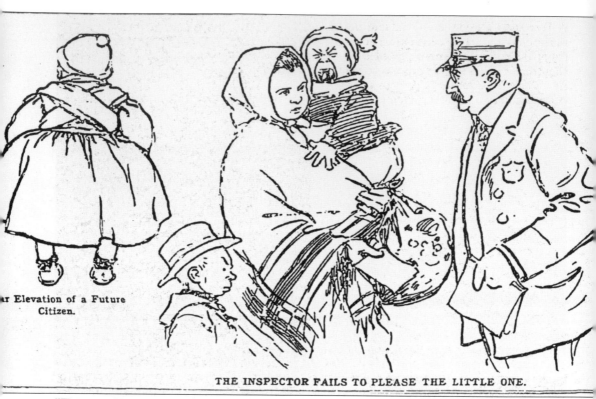

ar Elevation of a Future
Citizen.

THE INSPECTOR FAILS TO PLEASE THE LITTLE ONE.

"TOTS AT ELLIS ISLAND." This 1904 feature article on detained immigrant children on Ellis Island was clearly written to appeal to public sympathy and to charm readers. The reporter met the 12 matrons charged with taking care of the children, including head matron Regina Stucklen and her assistant, Sarah Denny. The article states that there were 200 detained children, including "black-eyed Italian bambinos, fair-haired 'Polacks' in quaint dresses that touch the ground and hide their bare feet, Roumanians, Austrians, Syrians, Arabs, Turks, Slavs, Huns, Finns, Swedes, Russians, West Indians, Welsh, Scotch and Germans." It further notes that children played and enjoyed themselves and had not the faintest idea of what their harassed parents were undergoing in order to get out of Ellis Island and into America. (The *Washington Post*, June 5, 1904, B7.)

A Teenaged Traveler. Not all immigrants were Europeans. This young immigrant's national identity is unknown; possible countries of origin might be the Cape Verde Islands, the West Indies, or perhaps a Latin American nation. (Culver Pictures.)

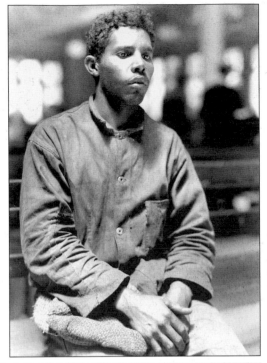

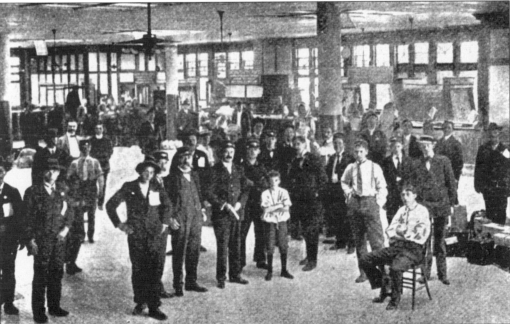

The Railroad Room. When immigrants were at last free to leave Ellis Island, they could purchase train tickets to just about anywhere in the United States or Canada. In fact, most immigrants—two-thirds of them—left the vicinity of New York within a few hours after getting off Ellis Island. Even many of those who had listed New York as their final destination left the city after a year or more: witness Irish immigrant Annie Moore, whose family eventually moved to Indiana. (National Park Service.)

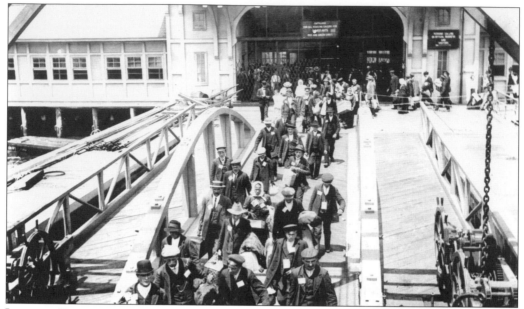

LEAVING ELLIS ISLAND. The long hours of waiting, medical examinations, and immigrant inspection were over, and the aliens were at last free to go, having won legal entry into the United States of America. This picture from the 1920s shows tagged immigrants on their way from the Ellis Island ferry house to the ferryboat *Ellis Island*, which transported them to the island of Manhattan. (Library of Congress.)

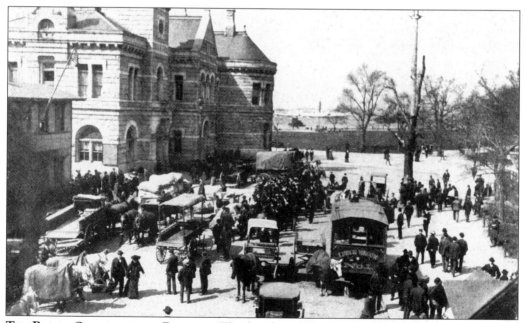

THE BARGE OFFICE AT THE BATTERY. The ferryboat *Ellis Island* transported freed immigrants to the tip of lower Manhattan at a place called the Battery or Battery Park. Here relatives or friends would meet some of the newcomers, while others would make their way into the city on their own. Plenty of transport was at everyone's beck and call, especially those taking the form of horse-drawn vehicles. A lunch wagon can also be seen. (National Park Service.)

Three

In Detention

Playing It by Ear

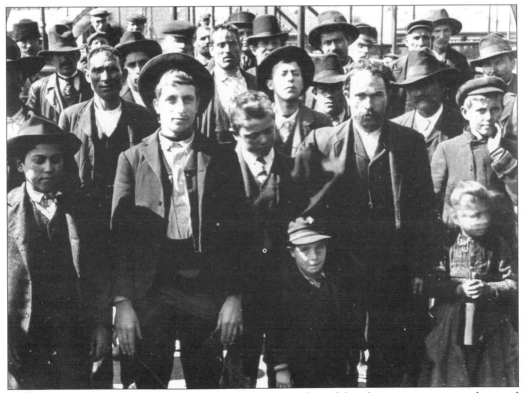

DETAINED BOYS AND MEN ON THE ROOF GARDEN. Male and female immigrants were detained separately. This fine scene on the Roof Garden tells us something of the hope these people felt, in spite of the temporary check delaying their immediate entry into the United States. After all, they must have heard that most detainees were eventually admitted. (National Park Service.)

CHILDREN ON ELLIS ISLAND.

Boy and Girl Held for Lack of Legal Guardianship.

Josefina Chinchilla, 15, and her brother Enrico, 7 years old, who arrived yesterday from Bogota, Colombia, on the United Fruit steamer Almirante, were sent to Ellis Island because they are under 16 and are not accompanied by their parents or legal guardians.

Mrs. Carmenedia Navarro, who had charge of the children from Bogota, said the father was dead, and as their mother was her cousin she had brought them to New York to be educated with her own children.

Agostino Castares, a brother of Mrs. Navarro, who says he is a merchant by occupation, and an Indian servant, Paolina Sarmiento, accompanied the party.

Mrs. Navarro had $4,000 with her in gold and appeared to carry the purse for the party, as none of the others had any money. They all went to Ellis Island and may be sent back to Colombia as being liable to become public charges, although only the two children were detained. The children were eating bananas and seemed very happy.

COLOMBIAN YOUTHS IN DETENTION. Stories of this sort, whether about children or grown-ups, appeared regularly in any numbers of newspapers. All over the nation, journalists knew that their readers were fascinated by the very human troubles that occurred at Ellis Island. Obviously, those caught in the web of bureaucratic red tape, rather than the happy majority that were released within a few hours, received the excited attention of newspaper readers. (The *New York Times*, October 29, 1915, 21.)

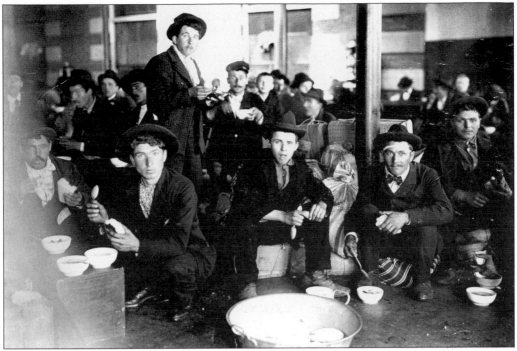

SUPPER TIME. Detainees eat soup or stew with bread in the New York Detained Room in 1903. It was often so busy at the station that immigrants brought over by an afternoon ferry could not be processed before the end of the immigrant inspectors' workday. Caught in this situation, many found themselves stuck for the night. (Carpenter Center, Harvard University.)

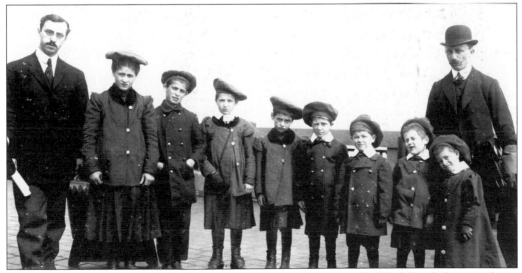

THE JEWISH ORPHANS. The Hebrew Immigrant Aid Society officials helped these orphans of a vicious Russian pogrom. The eight children, whose mothers had been killed in 1905, were brought to America on the Cunard Line's SS *Caronia* in May 1908. Philip Cowen, one of the inspectors at Ellis Island, was sent to Russia to investigate conditions there and wrote an extensive exposé of the anti-Jewish massacres going on. (Augustus Sherman photograph, National Park Service.)

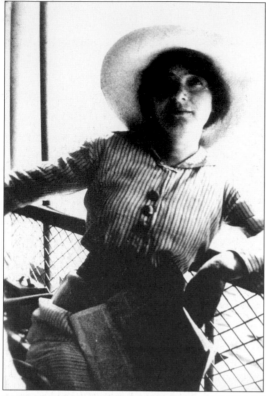

CECILIA GREENSTONE. Cecilia Greenstone was an immigrant aid worker at Ellis Island for 12 years (1907–1919). Representing the National Council of Jewish Women, her job was to help Jewish girls, underage boys, and young women by assisting them through the station and protecting them from every form of exploitation and imposition. She herself was a Russian immigrant, having passed through Ellis Island in 1905. Thus, it should come as no surprise that she had the command of several languages, including her native Yiddish and Russian. This picture was taken aboard the ferryboat *Ellis Island* around 1918. (National Park Service.)

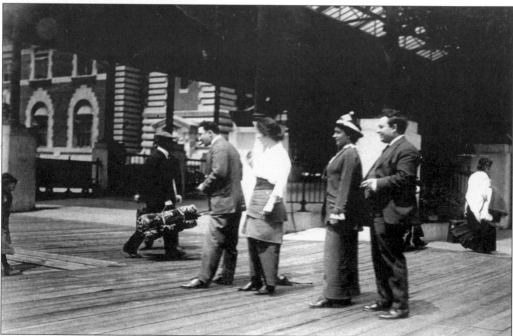

A LITTLE GIRL AND CECILIA GREENSTONE. Cecilia Greenstone and three other Jewish aid officials focus their attention on a small immigrant girl, the type of which she helped just about every day. (National Park Service.)

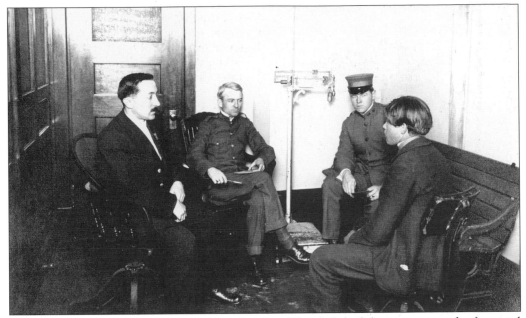

MENTAL TESTING OF AN IMMIGRANT YOUTH. This lad (right) was suspected of mental deficiency, or feeblemindedness. Here, around 1912, he is undergoing medical questioning at the hands of Dr. Howard A. Knox (wearing a hat), another uniformed Ellis Island physician, and an interpreter (far left). Several Ellis Island physicians, including Knox, Eugene Hagen Mullan, and Alfred C. Reed, developed special mental tests for immigrants. An earlier doctor, Thomas W. Salmon, also emphasized screening immigrants for mental deficiency. (William Williams Papers, New York Public Library.)

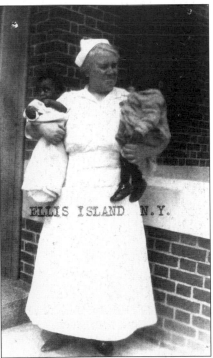

A NURSE WITH TWO BABIES. Nurse Jennie A. Colligan holds two of her charges around 1910. Though of African ancestry, the babies may have come from one of the islands in the Caribbean Sea such as Trinidad, Jamaica, or Barbados. The nurse, who worked in the children's ward, was affectionately called "Mother" by her coworkers. (National Archives, #125-63.)

35

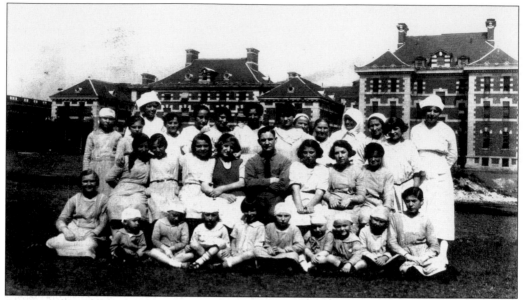

FIGHTING FAVUS. These 29 patients, mostly girls and boys, are taking the cure either for favus (the scalp disease) or lice. Such diseases and infestations were commonplace for immigrants. Poor conditions in Europe and other areas of the world gave rise to it, and then travel by emigrant train and in steerage over the sea helped the contagion to spread. (National Archives, #125-38a.)

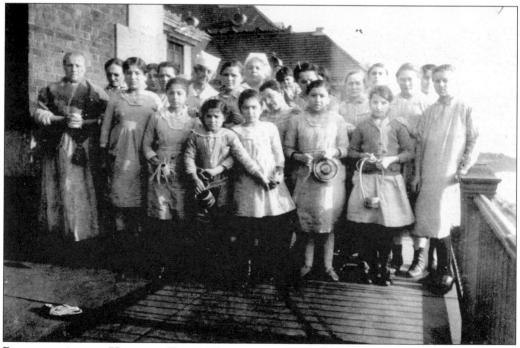

PATIENTS ON THE HOSPITAL ROOF. These immigrant girls and nurses pose for a photograph on one of the hospital rooftops. The youngsters show off some of the handicrafts that they had worked on during their stay in the hospital. The items appear to be baskets of straw or wickerwork. (National Archives, #125-52.)

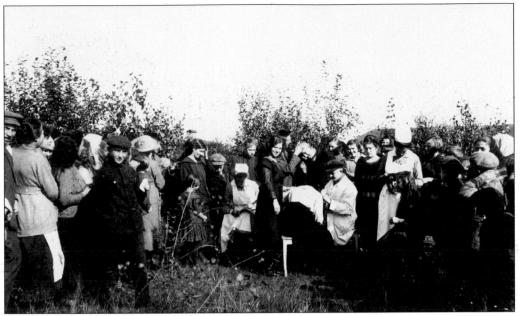

CONTROLLING LICE. Nurses help delouse young immigrants. Lice caused much distress and annoyance to immigrants, who either became infested with them during their sea voyage in steerage or who got them in their homelands long before setting out for America. (National Archives, #22D-31.)

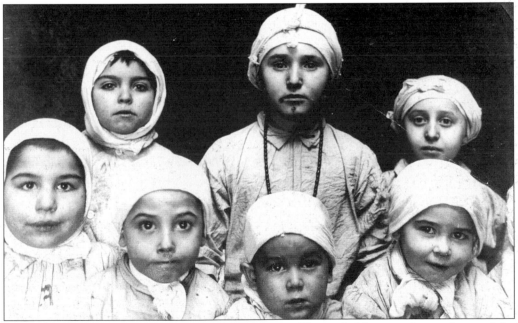

SEVEN CHILDREN AT THE IMMIGRANT HOSPITAL. These children are being detained for hospitalization for favus, a highly contagious disease of the scalp, which when severe made one's hair fall out. In those days, the treatment was to shave the head and keep the scalp washed and disinfected. (National Archives, #90-G-22-D-39.)

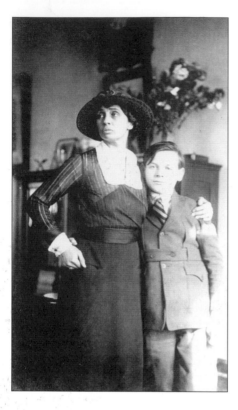

OSMAN LOUIS, BELGIAN STOWAWAY. Suddenly, the 13-year-old apprentice of Antwerp, Belgium, saw a chance of escape. The lad quietly crept aboard the *Cantigny*, an American army ship standing along the quayside. But when he arrived at New York, Osman Louis was promptly handed over to Ellis Island inspectors as a stowaway. Sick after the voyage, he was sent to the hospital. His recovery in February 1921 also marked his rescue by Col. Helen R. Bastedo, who posted a bond for his release. The freed boy from Belgium went to Chico, California. (Augustus Sherman photograph, National Park Service.)

FRENCH GIRL STOWAWAY. Ellis Island's inspectors had an ample number of stowaway cases to sort out every year. Aside from men and women, even boys and girls were sometimes stowaways. The temptation to slip aboard ship without paying the fare was irresistible to those with empty purses. The girl in this piece, Michele d'Idier, 15, hailed from Grenoble, France. Despite the favorable impression she made, she was nevertheless deported. (The *New York Times*, May 6, 1933.)

GIRL STOWAWAY, 15, LIKES 'GENDARME'

French Miss Slips In to See City, but Is Found Forlorn Standing in Doorway.

SHE CAPTIVATES A JUDGE

Justice Levy Gives Her a Present, but Sends Her to Ellis Island to Take Ship for Home.

Mlle. Michele d'Idier, 15 years old, of Grenoble, France, arrived on the liner Lafayette at 11:40 Thursday morning. She was a stowaway.

About fourteen hours later, Patrolman Kenneth Waters saw a demure young woman in a blue silk dress, leather windbreaker and wrinkled beret, standing rather forlornly in

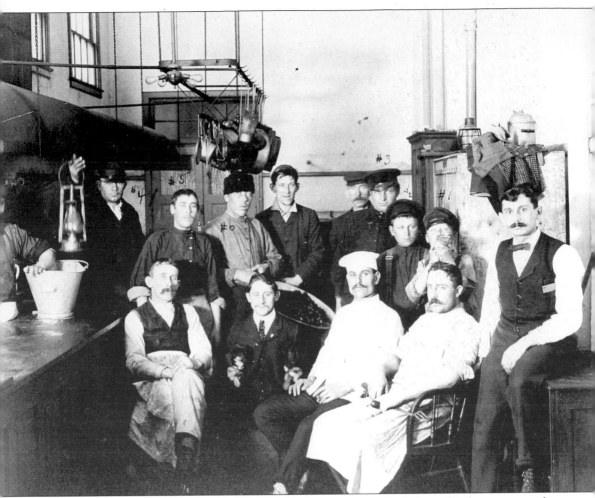

WORKING IN THE KITCHEN. Ellis Island kitchen workers—cooks, helpers, kitchen men, and one supervisor (far right) are pictured in 1901. Also shown are one or two detained immigrants who were forced to work in the kitchen without pay. Not unexpectedly, they were given the dirty work to do. (Terence V. Powderly Papers, Catholic University of America.)

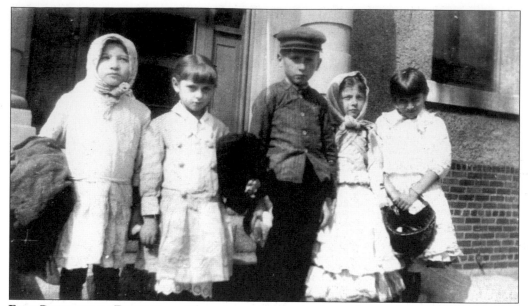

FIVE CHILDREN IN DETENTION. These five youngsters are being detained, probably because the parents have failed to satisfy the inspector as to their admissibility. Their problems usually ended on a happy note. (Augustus Sherman photograph, National Park Service.)

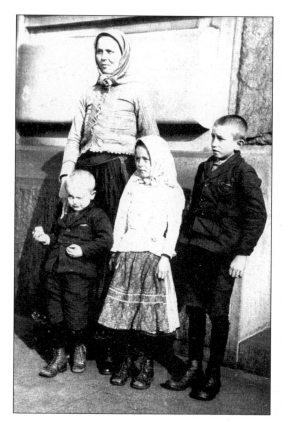

LUDMILA K. FOXLEE AND THREE CZECH CHILDREN. Wearing Bohemian garb, immigrant aid worker Ludmila K. Foxlee stands with two boys and a girl in the early 1920s. She, like the three children, was also a Czech. She worked at Ellis Island for the Young Women's Christian Association (YWCA), and one of her interests was in the folk and peasant costumes that so many immigrants wore when they arrived. (National Park Service.)

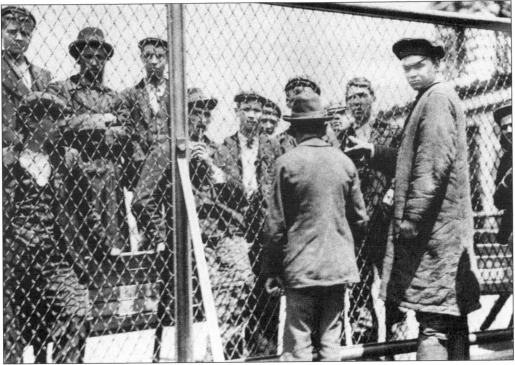

THE DETENTION PEN. This rooftop prison held crowds of detained immigrants. Escape was clearly frowned upon, as indicated by the formidable fence. The misery on the detainees' faces makes one doubt the claim that they enjoyed the rooftop's fine weather, sunshine, and lovely views.

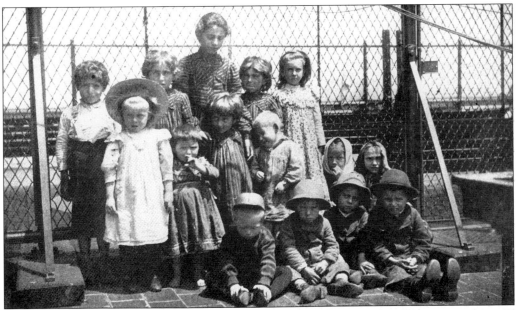

YOUNGSTERS ON THE ROOF GARDEN. Unaware of the full meaning of detention, these 15 children stand rather somberly in the Roof Garden in 1906, looking no happier than the men in the previous photograph. (Augustus Sherman photograph, National Park Service.)

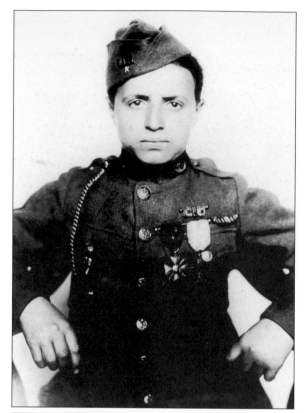

ENRICO CARDI, ITALIAN SOLDIER BOY. By the age of 15, Enrico Cardi had gone through a lot. Having shown his pluck as a soldier by capturing three German prisoners and being wounded three times in the course of battle, he was decorated with France's Croix de Guerre (War Cross). Next he came to the attention of the U.S. Army's 40th Engineers (Camouflage), who "adopted" him as an "honorary sergeant." After World War I, having told the Red Cross that he was an orphan, he was brought to New York on the SS *Patria*, which docked on May 10, 1919. At Ellis Island, inspectors released him to the custody of vaudeville star Elsie Janis (the "darling" of American troops in France), who adopted him. All went well until the truth came out: he was no orphan; someone discovered that his parents were very much alive and wanted him back. The wayward youth was returned to Ellis Island and was promptly deported. (Augustus Sherman photograph, National Park Service.)

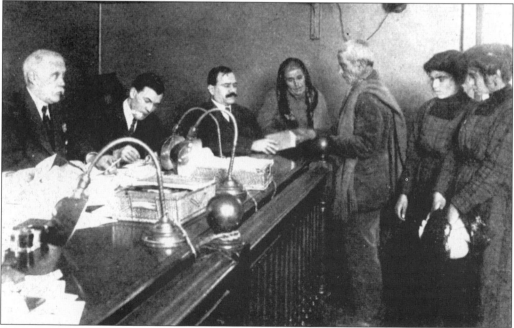

A BOARD OF SPECIAL INQUIRY HEARING. The fate of detained immigrants was decided by the inspectors of the Special Inquiry Division. These detainees, pictured around 1905, are from Italy. (Lewis Hine photograph, author's collection.)

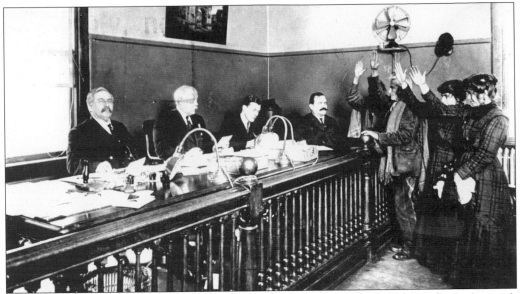

ITALIANS DEFENDING THEIR CASE. Four Italian detainees take the oath to speak the truth before the Board of Special Inquiry. An Italian interpreter (seated, far right) is there to translate. All detained immigrants were brought before such a board to defend their case and, hopefully, to win admission into the United States. Those whom the board ordered excluded or deported could make an appeal to the commissioner. If the commissioner supported the board's decision, the detainees could make a last appeal to an official in Washington, such as the secretary of labor. (Lewis Hine photograph, General Board of Global Ministries, United Methodist Church.)

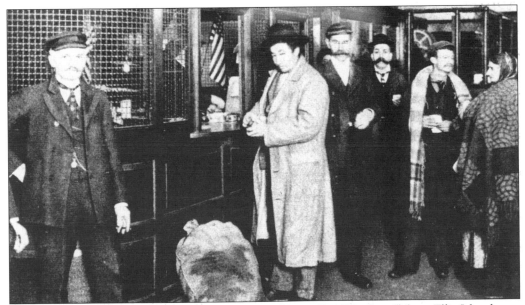

AT THE MONEY EXCHANGE AND TELEGRAPH BUREAU. Finally released from Ellis Island, one of a group of immigrants changes his foreign currency for dollars at the Money Exchange. The Telegraph Bureau (far right) was available to those wishing to wire (send word by telegraph to) relatives or friends announcing their release from Ellis Island. (Quarantine Sketches, National Park Service.)

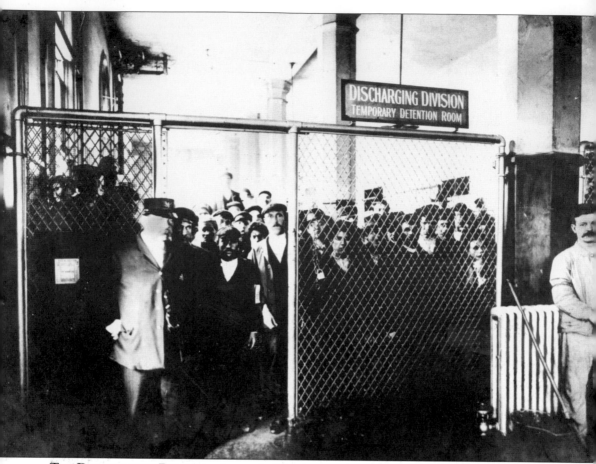

THE DISCHARGING DIVISION. A crowd of detainees awaits release in the Temporary Detention Room of the Discharging Division, one of 12 divisions operating on Ellis Island. Some detainees are waiting for a relative to come for them, others are waiting for money, and still others for the confirmation of an address. An inspector is in charge of the gate, and an attendant stands by the radiator. (American Jewish Historical Society.)

Four

DETAINED FAMILIES

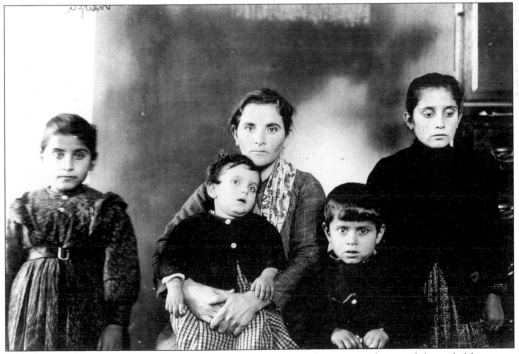

AN ARAB MOTHER WITH FOUR CHILDREN. An immigrant mother and her children are probably awaiting the arrival of her husband or another adult male relative. Although there were exceptions depending on the case, this was usually the only way most females could be released from Ellis Island. These immigrants are Christian Arabs from Lebanon, which was then still a part of Syria. (Augustus Sherman photograph, National Park Service.)

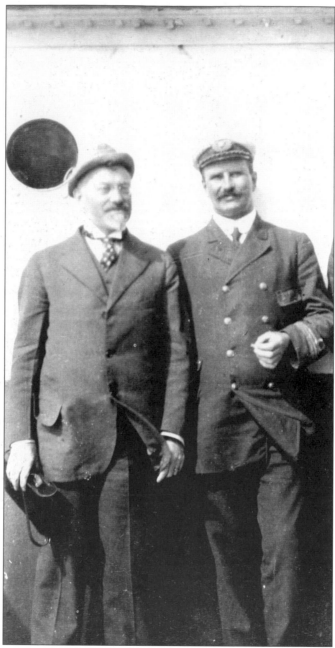

AUGUSTUS F. SHERMAN, PHOTOGRAPHER. The man on the left is none other than Augustus F. Sherman (1865–1925), the photographer who took scores of pictures of detained immigrants at Ellis Island, a number of which appear in this chapter. Sherman worked as an executive clerk at the station for 15 years. He eventually rose to the powerful position of chief clerk. In this post, he worked closely with some of Ellis Island's leading commissioners of immigration such as Robert Watchorn, William Williams, and Frederic C. Howe. Sherman's visual interests ran to unusual types, such as persons clothed in heavily embroidered folk costumes, large families, eccentrics, minor celebrities, and traveling show people. (Sherman Collection, National Park Service.)

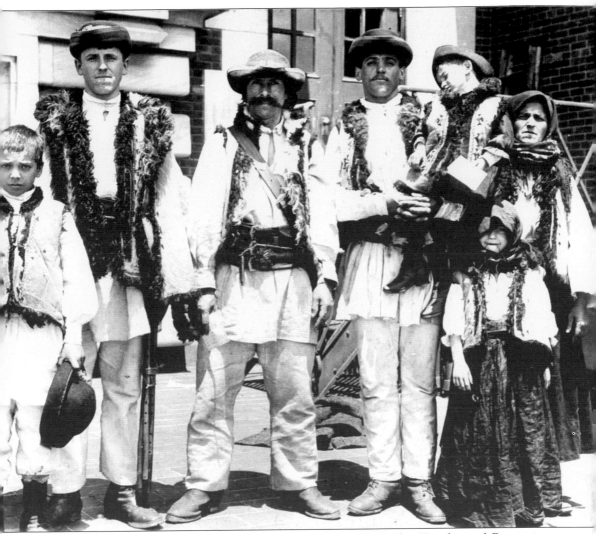

A Peasant Family in Detention. This family came from the Kingdom of Romania. Thousands of Romanian immigrants—members of the Romanian Orthodox Church—passed through Ellis Island. The men and boys were shepherds, but in America, most gave up their agricultural pursuits to seek jobs in factories, mills, and other urban places. (Augustus Sherman photograph, National Park Service.)

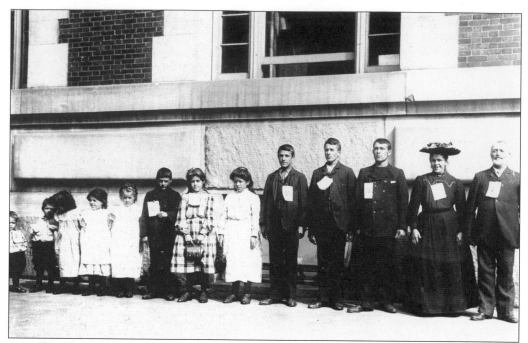

DINGENIS GLERUM WITH HIS WIFE AND 11 CHILDREN. *Mynher* (Mr.) and *Mevrouw* (Mrs.) Glerum pose proudly with their 11 offspring shortly before being released from Ellis Island. Such large families were common in those days. The Glerums were from the Kingdom of the Netherlands. Many Dutch immigrants settled in farm states such as Michigan, Missouri, Indiana, Nebraska, and Montana. (Augustus Sherman photograph, National Park Service.)

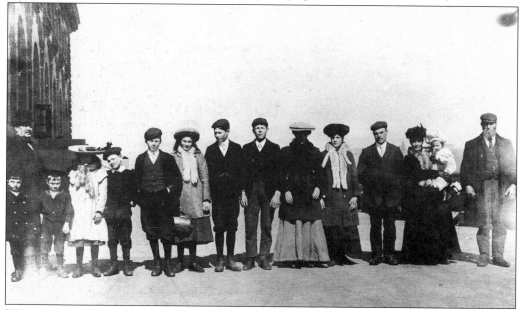

WELCOME TO AMERICA. Here presented for inspection is yet another family, to wit, a husband and wife with 12 children. This prosperous looking family was the type that usually had enough funds to buy their own farm, shop, or other business. (Augustus Sherman photograph, National Park Service.)

A FAMILY FROM FINLAND. These Finnish immigrants probably sailed from Helsinki to Copenhagen, Denmark, or Bremerhaven, Germany, and at one of these ports boarded a transatlantic steamer for New York. Until it achieved political independence in 1918–1919, Finland was ruled by Russia's tsar, who held the title grand duke of Finland. (Augustus Sherman photograph, National Park Service.)

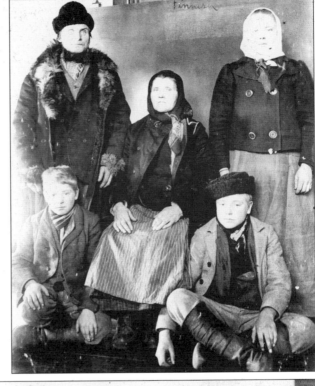

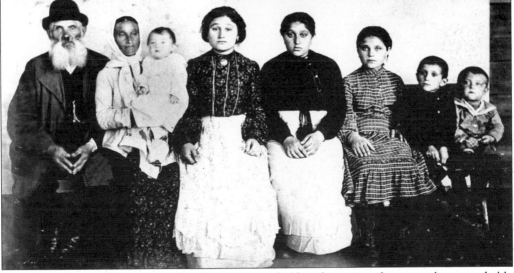

A JEWISH FAMILY. Like many other families being held in detention, these people are probably waiting for some technicality to be sorted out. The Hebrew Immigrant Aid Society sometimes had to intervene to help Jewish detainees win admission. The Jews were the third-largest nationality to pass through Ellis Island after the Italians and Eastern European Christians. Although they came from a variety of countries, the Bureau of Immigration refused to label them anything other than "Hebrew." The reasoning behind this policy was that Jews did not originate in Europe and hence could not be Europeans in a racial or ethnic sense. (Augustus Sherman photograph, National Park Service.)

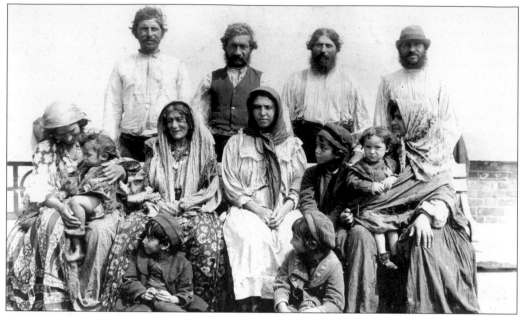

A Gypsy Family. Thousands of *Romas*, more commonly known as Gypsies, passed through Ellis Island. Most of them sailed from European ports, although some also sailed from Latin America. This family was from the Kingdom of Serbia. Gypsies often satisfied inspectors as to their admissibility by showing them how much silver they possessed—often quite a lot. In Europe, they were known by several names—in Russia and Eastern Europe as *Tsiganes*, in France as *bohemiens*, in Germany as *Zigeuner*, in Spain as *gitanos*, and in England as "Egyptians," or Gypsies. Although a great number of Gypsies settled in the western states, others could be found in every region of the country. (Augustus Sherman photograph, National Park Service.)

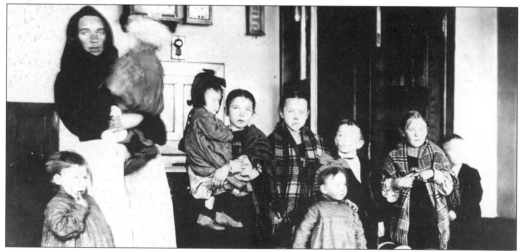

A Polish Mother and Her Nine Children. Thousands of Poles had already passed through Ellis Island before this woman arrived and was photographed with her nine children in 1923. Many Polish communities and neighborhoods flourished in a great many American cities and towns. Many settled in Illinois, Ohio, New York, New Jersey, Indiana, and Michigan. The Poles were strong supporters of the Roman Catholic Church. (Augustus Sherman photograph, National Park Service.)

A Well-Fed Russian Baby.
This 11-month-old baby weighed 55 pounds. Photographer Augustus Sherman enjoyed taking pictures of such unusual immigrants. Among his other subjects were Wladek Zybysko, a famous Polish wrestler; Mary Johnson, alias Frank Woodhull, a woman who for 15 years had dressed in men's clothes; and circus entertainers, labeled as "freaks," from Bombay (Mumbai), India. (Augustus Sherman photograph, National Park Service.)

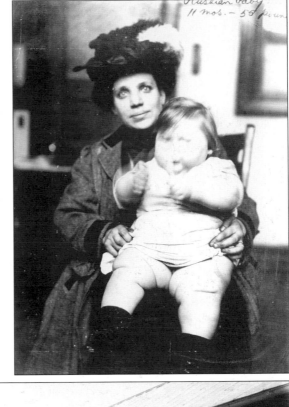

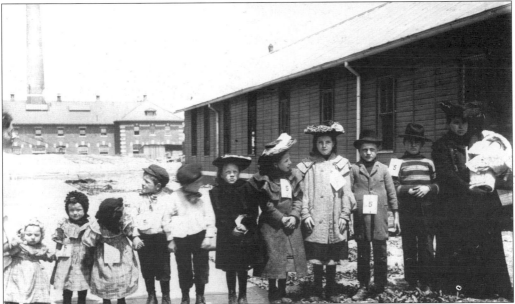

Johanna Dykhof with Her 11 Children. This family from Lithogen, Holland, was bound for Minnesota. Gerardus and Johanna Dykhof and their children had sailed to New York aboard the SS *Noordam*, arriving on May 12, 1908. The children were Johan, 12; Frans, 11; Cato, 10; Anna, 9; Allegonda, 9; Willem, 8; Marinus, 7; Marjarnne, 6; Jacoba, age uncertain; Josephien, 2; and "baby." The Dykhofs had $1,092 and intended to farm in Minnesota. (Augustus Sherman photograph, National Park Service.)

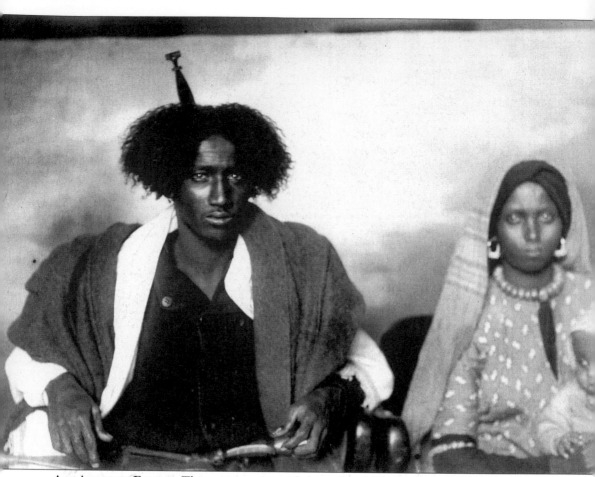

An African Family. This young man with his wife and baby were of the Boruna people. They immigrated with a large group that was probably an extended family. The Borunas lived mainly in southern Abyssinia and northern Kenya. Genuine African immigrants were a rarity at Ellis Island; most black immigrants at the station were from the British West Indies. (Augustus Sherman photograph, National Park Service.)

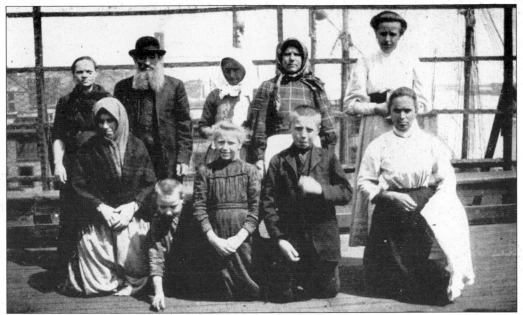

RUSSIAN JEWS. This family typifies the vast exodus of Jews from the Russian Empire. Cruel poverty, relentless discrimination and bigotry, and occasional massacres forced scores of them to leave. About 1.8 million Jews entered the United States through Ellis Island; most of them were Russian. Although some efforts were made to encourage them to settle elsewhere, most Jewish immigrants preferred to remain in New York or other northeastern cities. (Author's collection.)

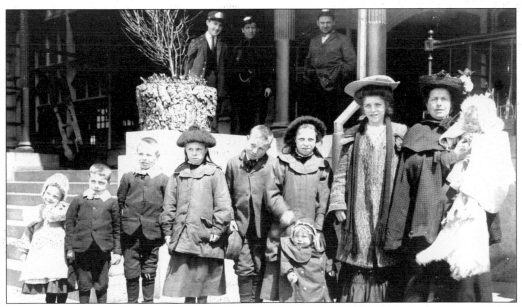

AN ENGLISH FAMILY. England, America's mother country, continued sending many of its subjects to the United States. Here an Englishwoman with nine children poses on April 17, 1908. The family came to America aboard the SS *Adriatic*, a steamer of Great Britain's White Star Line. English families fit well into American society for, in those days, most Americans were of British ancestry. (Augustus Sherman photograph, National Park Service.)

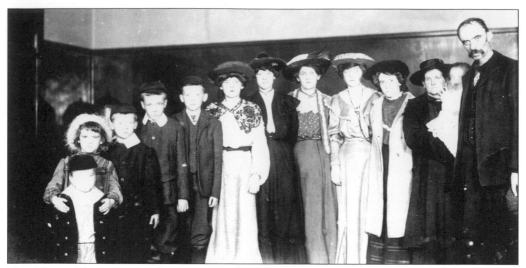

THE THIRD FAMILY FROM SCOTLAND. John D. Third brought his family to America aboard the *Caledonia*. The steamer, owned by the Anchor Line, sailed from Glasgow to New York. In this September 1905 photograph are, from left to right, Edward, Elsie, Alexander, William, John, Annie, Barbara, and Mary Jane Third, Margaret Garrett (a friend), Mary Third, Christine Cassell Third, baby Charles Third, and John Duncan Third. The family went to Anniston, Alabama. Their descendants have a family reunion at Anniston every three years. (Augustus Sherman photograph, National Park Service.)

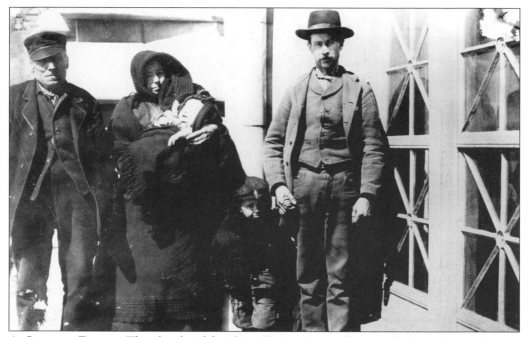

A GERMAN FAMILY. This family of five from Germany was photographed on the rooftop on the north side of the Main Building. Some 600,000 German immigrants passed through Ellis Island. Many settled in Wisconsin, Indiana, Ohio, Missouri, Texas, and California. Among the well-known German immigrants to pass through Ellis Island is media tycoon John Kluge, who arrived at the age of eight in 1922. (Augustus Sherman photograph, National Park Service.)

Five

CHILDREN IN DETENTION

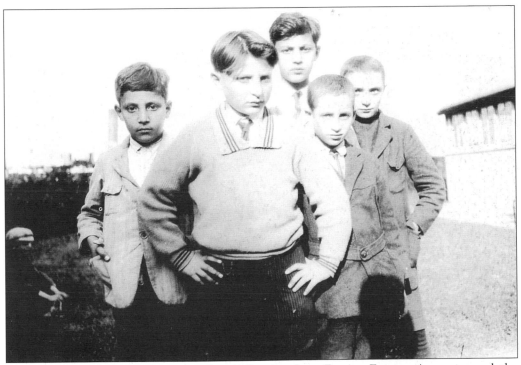

A MIXED GROUP OF IMMIGRANT BOYS. Coming from Eastern Europe, Armenia, and the Balkans, these lads played a good many games together during their stay at Ellis Island in 1924. Jacob Lalgran (center back) was later deported. (Frank L. Moore photograph, Amistad Research Center, Tulane University.)

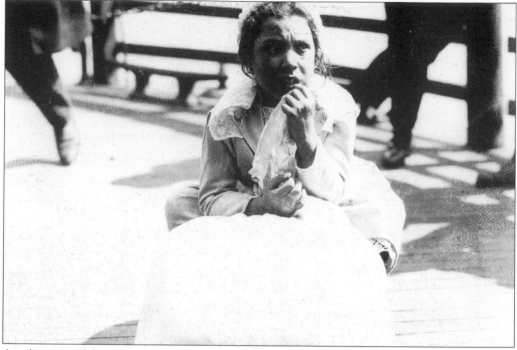

AN ANXIOUS MOMENT ON THE FERRY. This distressed child is riding on a ferryboat to Ellis Island. She has a great bundle with her. The picture was taken in 1921. (Frank L. Moore photograph, Amistad Research Center, Tulane University.)

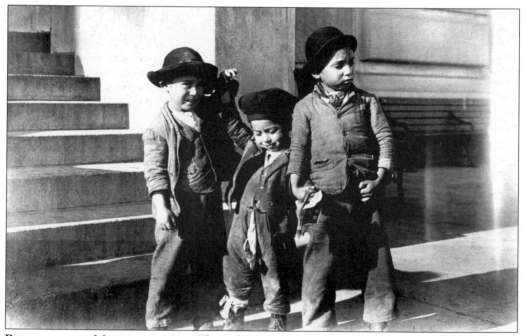

BOYS FROM THE MEDITERRANEAN. The Italians—three million of them—were by far the largest nationality to pass through Ellis Island. These Italian immigrant boys were photographed early in the 20th century. (Augustus Sherman photograph, National Park Service.)

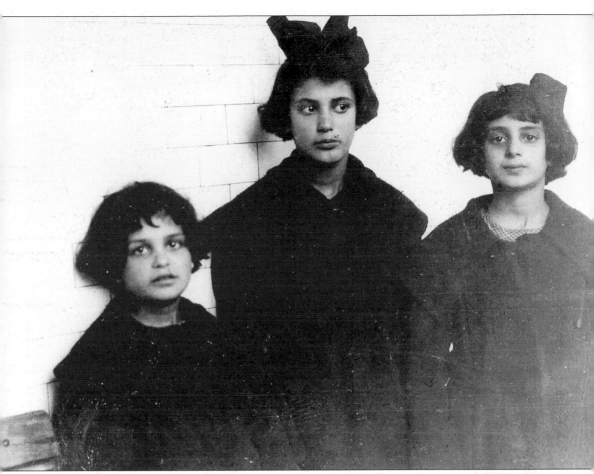

THREE ARMENIAN SISTERS. Dressed in black, these three sisters came from Armenia. The picture was taken in 1921. Christian missionaries assisted many Armenian immigrants, especially girls, when they landed at Ellis Island. (Frank L. Moore photograph, Amistad Research Center, Tulane University.)

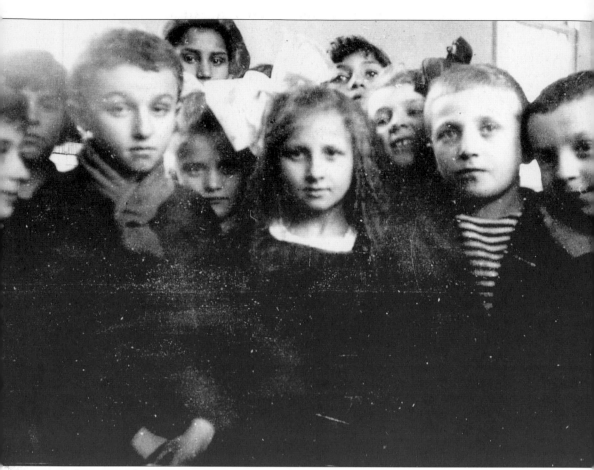

A Group of Children in Detention. The very interesting faces of these children conjure up ideas and fancies of what life was like for them at Ellis Island. The photograph dates from 1921. (Frank L. Moore photograph, Amistad Research Center, Tulane University.)

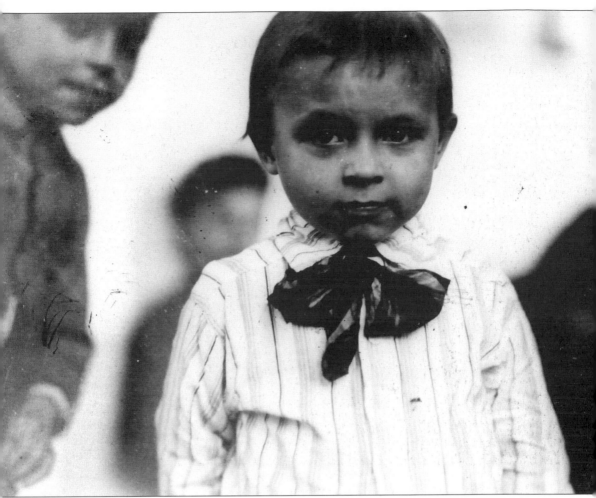

"Glad to Get to America from Central Europe." Frank L. Moore, a photographer for the American Missionary Association, took and captioned the picture of this lad in 1921. (Frank L. Moore photograph, Amistad Research Center, Tulane University.)

JACOB LALGRAN. Young Jacob Lalgran was briefly detained at Ellis Island in 1924 and then was deported to Mexico, where he had to live for a year in order to gain residency in the western hemisphere and thus avoid the quota restrictions. This dodge was useful since he was eligible to reenter the United States as a lawful Mexican resident. Many Europeans had to do this in 1921 and in later years because the continents of Europe, Asia, and Africa could send only relatively small numbers of immigrants to the United States under the restrictive quota laws. Countries in the western hemisphere were quota free. (Frank L. Moore photograph, Amistad Research Center, Tulane University.)

JOHN MUSGROVE. In 1924, John Musgrove came to the United States with his family. He was detained because he had only one leg. After failed attempts by his family to guarantee that he would not become a public charge and so win his release, the family was deported back to England. (Frank L. Moore photograph, Amistad Research Center, Tulane University.)

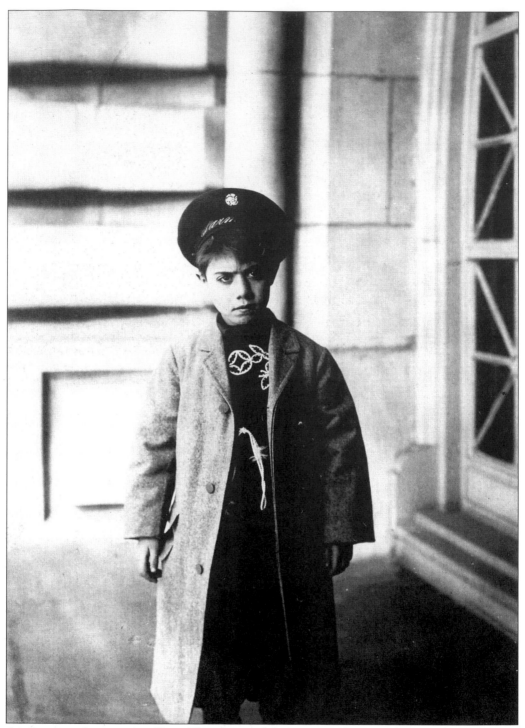

AN ITALIAN IMMIGRANT BOY. This detained Italian was photographed on the rooftop of the Main Building. Numbering three million immigrants, the Italians were far and away the largest foreign nationality to pass through Ellis Island. (Augustus Sherman photograph, National Park Service.)

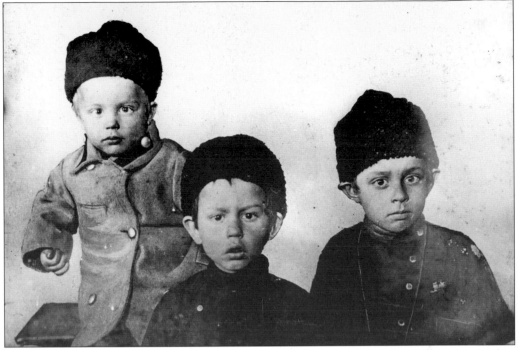

THREE RUSSIAN BOYS. These boys wear the heavy woolen caps of their far-off homeland. They look as though they have endured very much indeed and have not quite recovered from the weariness of the sea voyage. (Brighton Evangelical Congregational Society.)

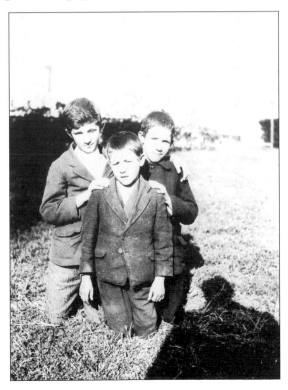

TWO SERBS AND A FRIEND. Two Serbian boys (rear) have made a friend at Ellis Island. Here they pose in the early 1920s for the American Missionary Association's photographer. (Frank L. Moore photograph, Amistad Research Center, Tulane University.)

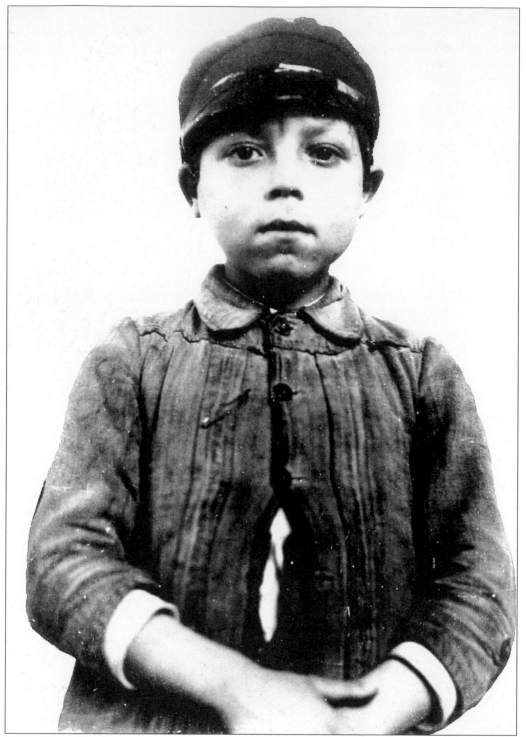

"All Boy." The photographer's caption describes this boy, posing in 1921. Regrettably, the boy's country of origin was not written down on the picture. (Frank L. Moore photograph, Amistad Research Center, Tulane University.)

"ENGLISH IS GREEK TO HER." This caption from photographer Frank L. Moore indicates that the girl did not speak a word of English. Regrettably, he did not note the language she did speak. Had he done so, this might have given us a line as to her nationality. (Frank L. Moore photograph, Amistad Research Center, Tulane University.)

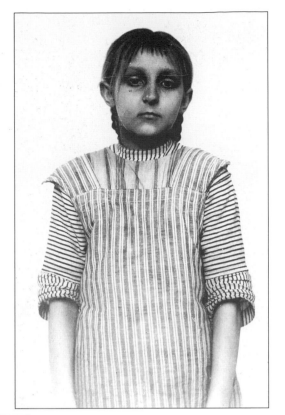

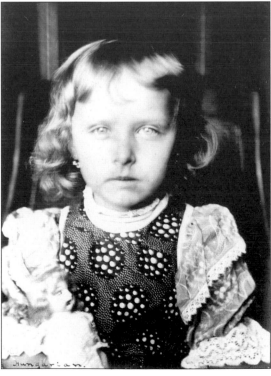

A HUNGARIAN GIRL. This Hungarian peasant wears a charmingly made frock with lace embroidery. Such costumes indicated an immigrant's home province, region, or even village. (Augustus Sherman photograph, National Park Service.)

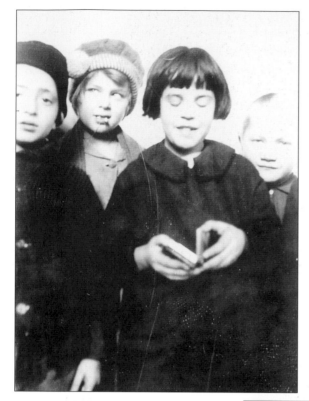

CHILDREN FROM THE ISLAND OF MALTA. Considering its size, the tiny nation of Malta sent a surprisingly impressive number of immigrants to the United States. The island, which lies in the Mediterranean Sea off the coast of North Africa, has its own language, Maltese. The language is a Semitic one, a sister tongue to modern Arabic and Hebrew, as well as to the ancient languages Assyrian and Babylonian. Like the other languages spoken in the islands of the Mediterranean—most notably, Corsican and Sardinian—Maltese has been influenced by more powerful countries, in this case Italy and England. Although Maltese immigrants brought their distinctive language to the United States, its use here did not endure long. A great many Maltese settled in Detroit, Michigan. (Frank L. Moore photograph, Amistad Research Center, Tulane University.)

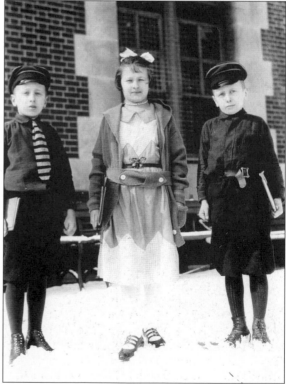

THREE JEWS FROM RUSSIA. A sister and two brothers were detained at Ellis Island for several months before finally being released. The picture was taken on a snowy day in the early 1920s. (Frank L. Moore photograph, Amistad Research Center, Tulane University.)

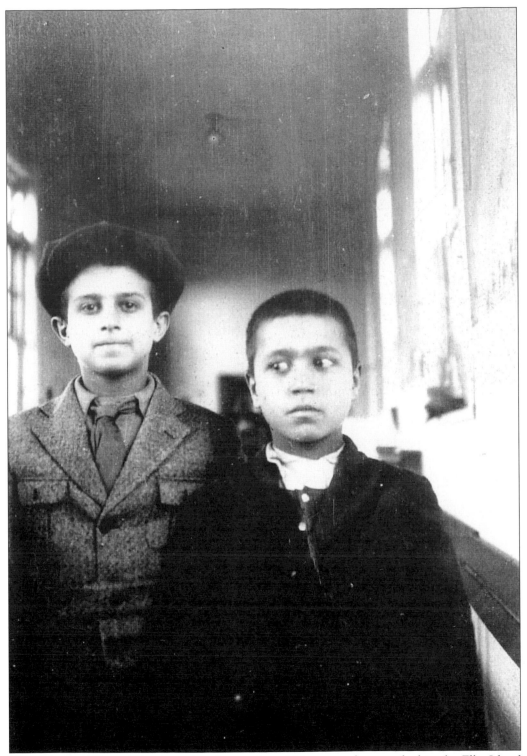

TWO MALTESE BOYS. These two immigrants from Malta were photographed in the Ellis Island schoolroom in 1922. (Frank L. Moore photograph, Amistad Research Center, Tulane University.)

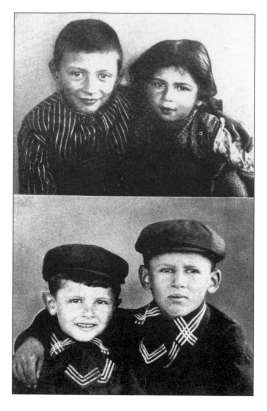

PORTUGUESE AND SPANISH CHILDREN. These four youngsters were from the two kingdoms of the Iberian Peninsula: Portugal and Spain. The Portuguese boy and girl are obviously brother and sister, and the two Spaniards are probably brothers. They were photographed at Ellis Island around 1905. (National Park Service.)

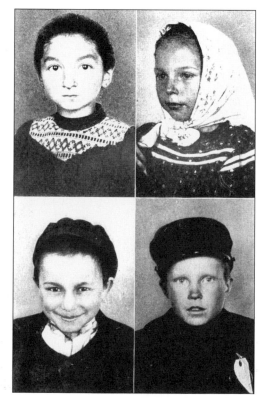

FOUR NATIONALITIES. These four children are listed as Jewish and Polish (above) and Italian and Spanish (below). Large numbers of Jews, Poles, and Italians emigrated each year to America; immigration from Spain was far lower. This was because most Spaniards chose to emigrate to one of Spain's former colonies in Latin America. This picture dates from about 1905. (National Park Service.)

KINDERGARTNERS. These children were held only temporarily at the station. They passed much of their time in the Ellis Island kindergarten, which was a sort of nursery school. They were released to their father, S. C. Cozzo, who lived in Grantwood, New Jersey. (Frank L. Moore photograph, Amistad Research Center, Tulane University.)

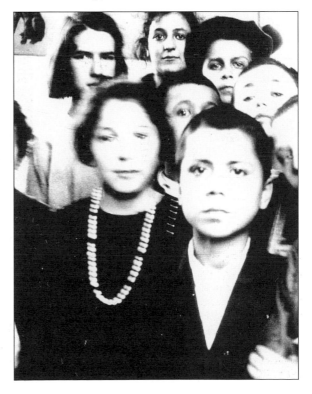

CHILDREN IN THE SCHOOLROOM.
This picture of eight detainees was taken in 1921 or 1922. Some of the children are from Malta. (Frank L. Moore photograph, Amistad Research Center, Tulane University.)

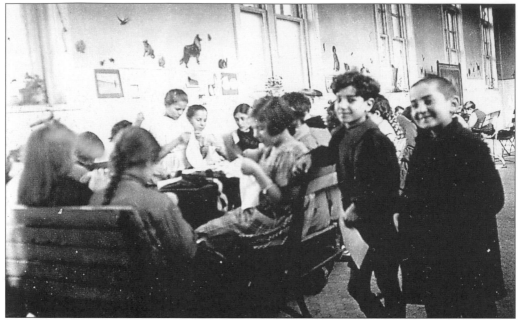

THE SEWING CLASS. The girls sewing here are receiving visitors: two boys. The boy with long hair is standing next to his sister, who is engaged in her work. The other boy is his friend. (Frank L. Moore photograph, Amistad Research Center, Tulane University.)

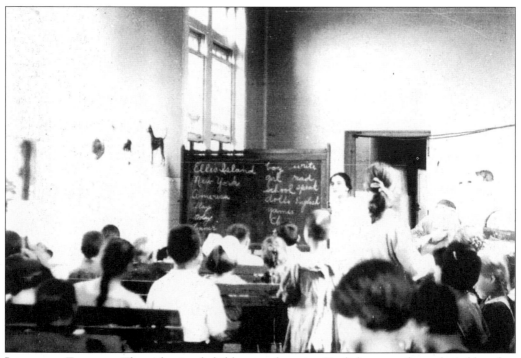

LEARNING ENGLISH. These detained children are learning English, as can be gathered by what is written on the blackboard. Some of the words are "Ellis Island," "New York," and "America." (Frank L. Moore photograph, Amistad Research Center, Tulane University.)

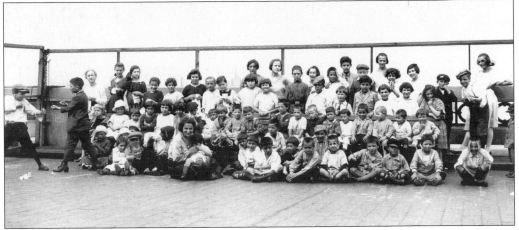

WATCHING THE BIRDIE. This group photograph shows detained immigrants and their teachers on the Roof Garden in 1924. Two of the boys (far left) seem more interested in pretending to be boxers than in striking a sedate pose for the cameraman. In this era, boxing was widely popular with boys. Fighters of the day included Luis Firpo, Jack Dempsey, Gene Tunney, Georges Carpentier, and Jack Sharkey. (Frank L. Moore photograph, Amistad Research Center, Tulane University.)

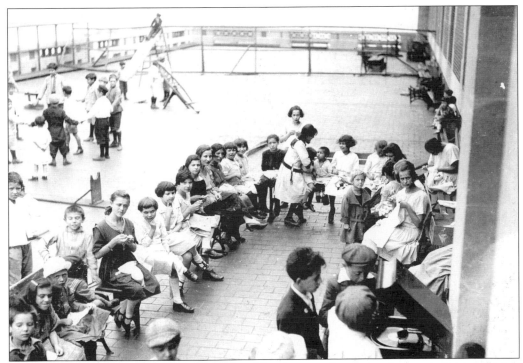

NEEDLES AND MUSIC IN THE AIR. The Roof Garden was the scene of many activities. In this 1924 photograph, immigrant girls practice with needle and thread in the sewing class while boys crowd around the phonograph machine, possibly a Victrola or gramophone, to listen to a record. Television did not exist in those days, and radio was still in its infancy. Most people listened to recordings of music, vaudeville acts, or lectures. (Frank L. Moore photograph, Amistad Research Center, Tulane University.)

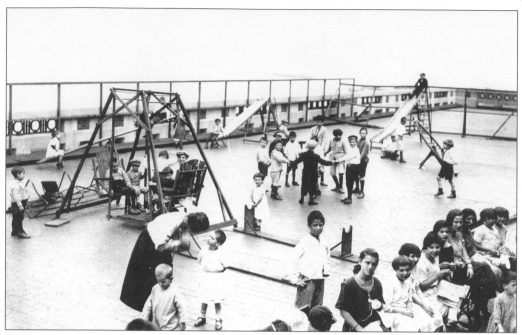

SOME SLIDES, A SWING, AND A DANCE. Children play on the swing, slides, and seesaw, while a group of boys engages in some sort of folk dance or game. The picture was taken in 1924. (Frank L. Moore photograph, Amistad Research Center, Tulane University.)

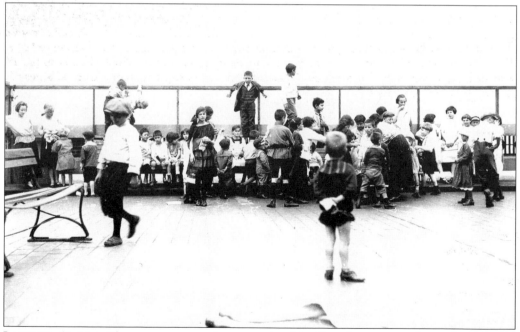

LARKING ABOUT. The group seems to have restricted itself to the vicinity of some benches for this 1924 picture. (Frank L. Moore photograph, Amistad Research Center, Tulane University.)

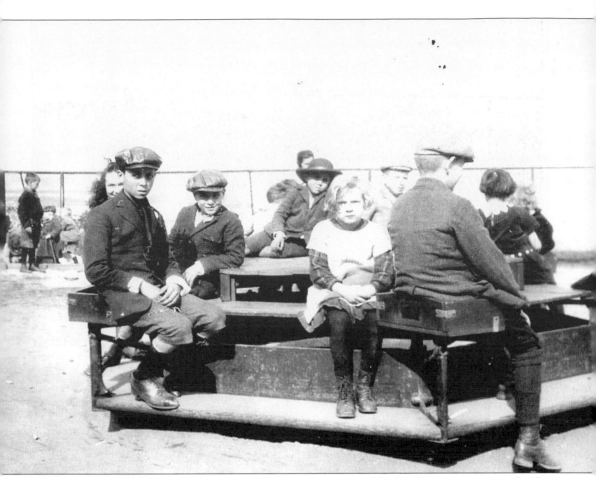

ON THE MERRY-GO-ROUND. A group of detainees waits patiently for the cameraman to finish the picture so that they can make merry on this old-fashioned roundabout. The boys are all wearing hats, mostly either leather or cloth caps. (Frank L. Moore photograph, Amistad Research Center, Tulane University.)

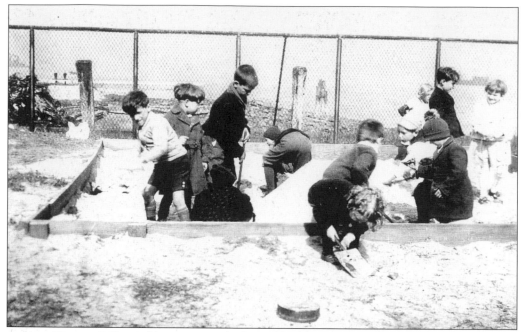

AT THE SANDPILE. Several boys vigorously dig and build in the sandpile. It would be interesting to know what they have agreed to design. This was one of the many diversions organized to keep detained children happy and out of mischief. (Frank L. Moore photograph, Amistad Research Center, Tulane University.)

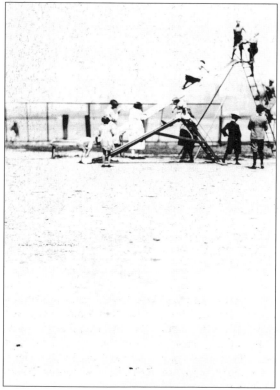

PLAYING ON THE SLIDES. About a dozen children gather to play on two slides. (Frank L. Moore photograph, Amistad Research Center, Tulane University.)

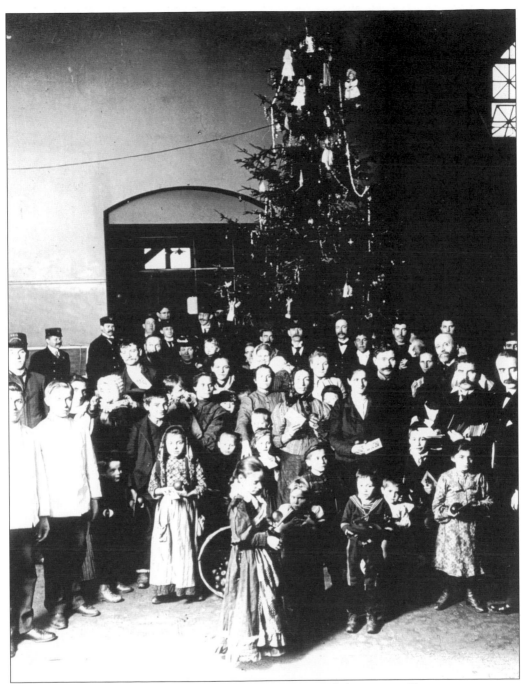

ELLIS ISLAND CHRISTMAS. The Bureau of Immigration and the various Christian missionary societies sponsored this 1905 Christmas party for detained immigrants. Children were given apples and other presents, and everyone apparently was handed Protestant religious tracts written in their respective languages. A number of inspectors and interpreters and two boy attendants (in white) stand at the side. Baptist Church missionary Michael Lodsin (far right) holds an armload of scriptural tracts to give out, and Commissioner Robert Watchorn stands next to him. (State of Wisconsin Historical Society.)

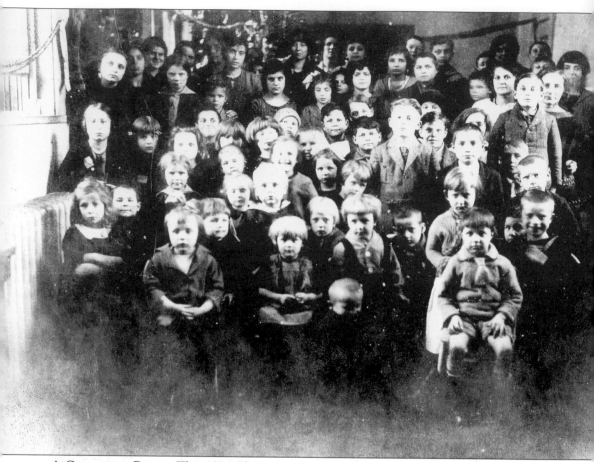

A Christmas Party. This 1924 Christmas party was thrown by the Congregational Church missionaries who operated the Ellis Island school. Although these children are dressed differently from those in the picture on the previous page, they received similar presents: fruit, sweets, games, and dolls. (Frank L. Moore photograph, Amistad Research Center, Tulane University.)

Six

CHILDREN IN COSTUMES

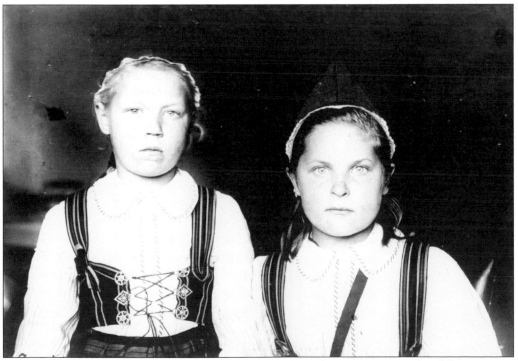

SWEDISH GIRLS. These girls from the Kingdom of Sweden are wearing the folk costumes traditional to Leksand, Sweden. An estimated 300,000 Swedes passed through Ellis Island. (Augustus Sherman photograph, National Park Service.)

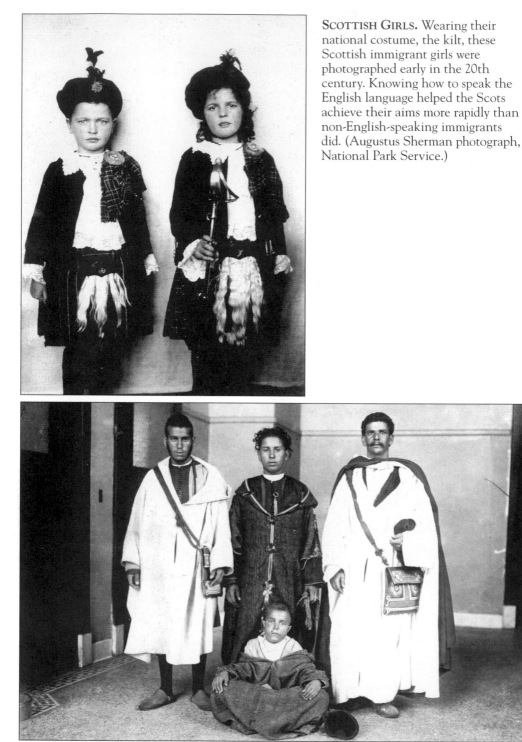

SCOTTISH GIRLS. Wearing their national costume, the kilt, these Scottish immigrant girls were photographed early in the 20th century. Knowing how to speak the English language helped the Scots achieve their aims more rapidly than non-English-speaking immigrants did. (Augustus Sherman photograph, National Park Service.)

MOROCCANS. Only a few thousand Arab Muslims immigrated to the United States through Ellis Island. These three young men and the seated boy hailed from the Sultanate of Morocco. (Augustus Sherman photograph, National Park Service.)

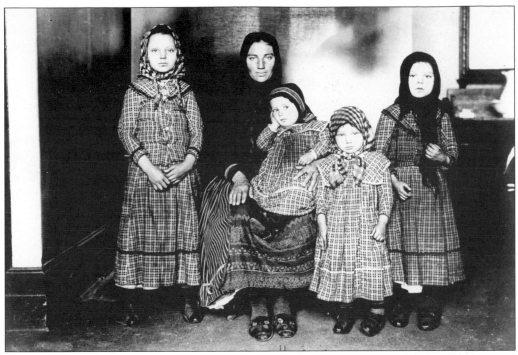

A Hungarian Mother and Four Daughters. A very interesting picture of a detained Hungarian family shows the identical homemade clothes that this mother must have fashioned for her children. (Augustus Sherman photograph, National Park Service.)

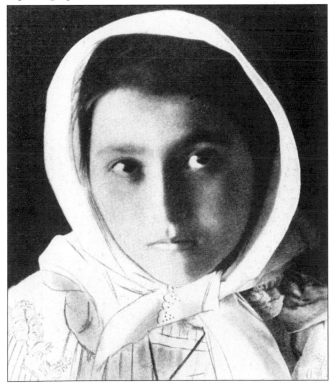

A Swiss Girl. This picture of a Swiss immigrant girl dates from about 1905. More than 1,000 immigrants from Switzerland passed through Ellis Island. (National Park Service.)

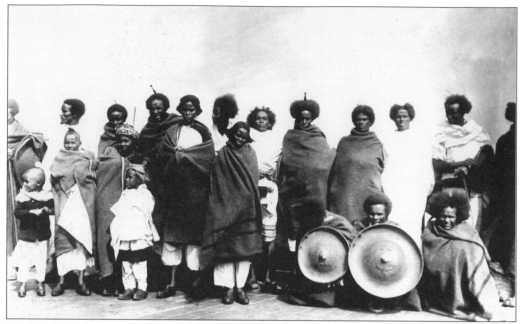

AN AFRICAN FAMILY. A Boruna family is pictured on the Roof Garden. The Borunas came mainly from southern Abyssinia and northern Kenya. (Augustus Sherman photograph, National Park Service.)

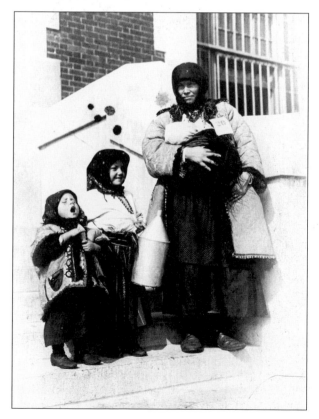

WALLACHIANS. This mother and her three children were Wallachians and, hence, Austro-Hungarian subjects. Nowadays the province of Wallachia is a part of Romania, and, in the Romanian language, it is called as Valahia. (Augustus Sherman photograph, National Park Service.)

SLOVAKS. This young mother and son came from Slovakia, a Roman Catholic country nestled in Eastern Europe. The woman is dressed in a richly embroidered peasant costume. (Augustus Sherman photograph, National Park Service.)

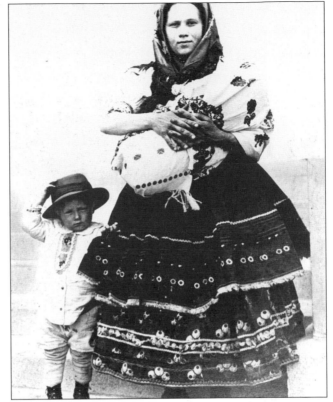

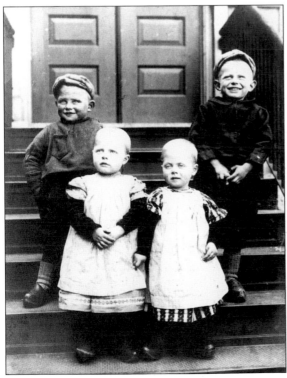

FOUR CHILDREN. These four siblings appear to be from the Netherlands. (Augustus Sherman photograph, National Park Service.)

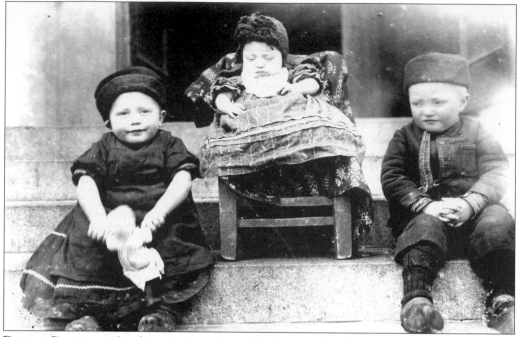

DUTCH CHILDREN. On this occasion, the usually buoyant Dutch youngsters are looking a trifle wilted. Perhaps the picture taking was beginning to tire them. They came from the Island of Marken. (Augustus Sherman photograph, National Park Service.)

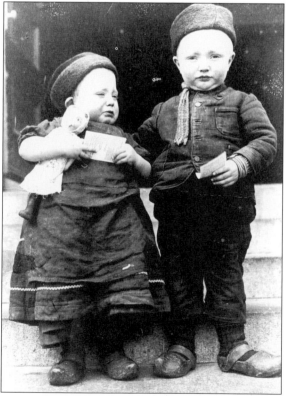

A DUTCH BROTHER AND SISTER. The same two children appear without their little sister. Note that they are holding Protestant religious tracts and that the girl is holding a doll. (Augustus Sherman photograph, National Park Service.)

SWEDISH CHILDREN. The Swedes often wore remarkably distinctive folk costumes, as seen in this photograph. (Augustus Sherman photograph, National Park Service.)

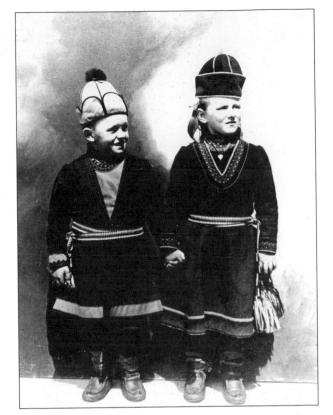

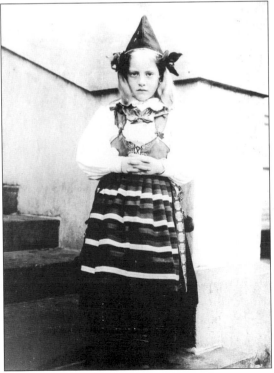

A SWEDISH GIRL. This little girl is from Rättvik in the province of Dalarna, in west-central Sweden. Her conical hat and the style and design of her dress and other garments reveal her regional origins. (Augustus Sherman photograph, National Park Service.)

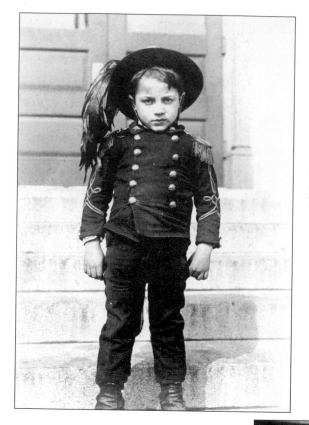

AN ITALIAN BOY. The Italians were fond of dressing their boys up in all sorts of ornate and florid costumes and miniature uniforms. Note the rich plumes in his hat. Italian immigrants strongly identified with their native provinces and towns rather than Italy as a whole. Hence, few referred to themselves as Italians. Instead, they called themselves Neapolitans, Calabrians, Tuscans, Sicilians, and so on. (Augustus Sherman photograph, National Park Service.)

A SCOTTISH LAD AND LASSES. With the magnificence of their kilts and adornments, the Scots could match just about any immigrants when it came to national and folk costumes. These three are probably siblings. (Augustus Sherman photograph, National Park Service.)

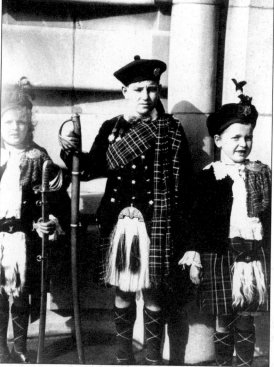

A Detained Girl. Dressed ornately in her folk costume, a detained immigrant shows off her knitting and her wooden shoes. She is probably from one of the lands of northern or western Europe. (Augustus Sherman photograph, National Park Service.)

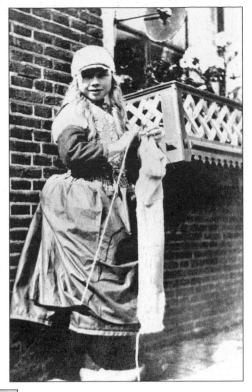

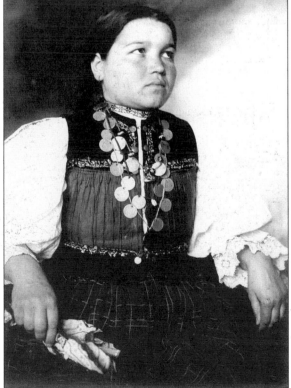

Hungarian Girl. A Hungarian immigrant wears a beautifully made folk dress and a necklace of coins or medallions. She clutches what appears to be a richly embroidered handkerchief. (Augustus Sherman photograph, National Park Service.)

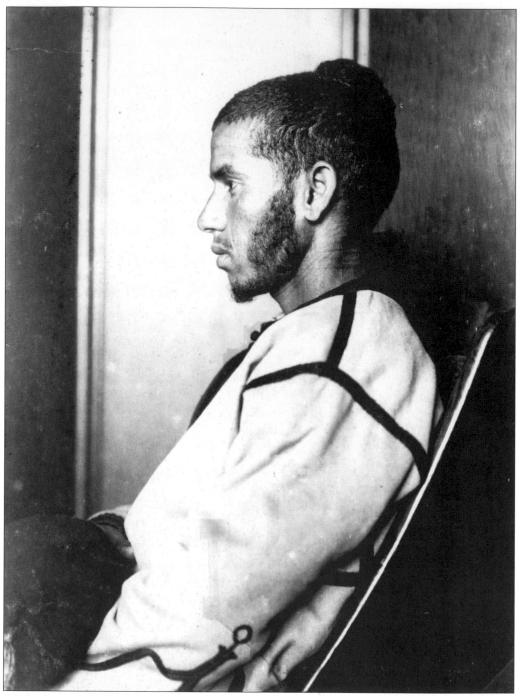

A MOROCCAN BOY. This young man is one of the four Moroccans appearing on page 78. This profile view of the Arab shows the rather anthropological approach to photography that Augustus Sherman employed. The emphasis seems to be—as in very nearly all of his pictures—weighed in favor of the study of race and ethnicity. Such a preoccupation is unsurprising, given the vast array of human types that he dealt with on Ellis Island during his workweek. (Augustus Sherman photograph, National Park Service.)

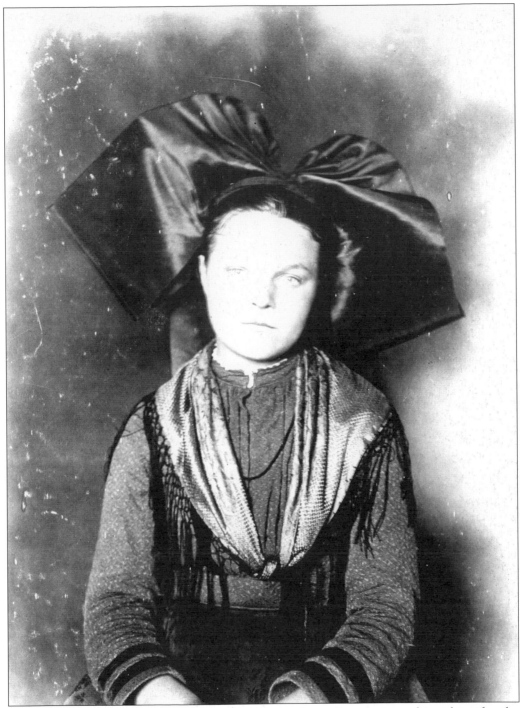

A GIRL OF ALSACE. Dressed in the costume distinctive to her province, this girl typifies the diversity of both France and Germany, for notwithstanding Alsace's preferred identification with France and French civilization, she was indisputably a part of Germany's Second Reich at the time of her emigration. Most notable is her elegant headdress, which is profoundly and inescapably Alsatian. (Augustus Sherman photograph, National Park Service.)

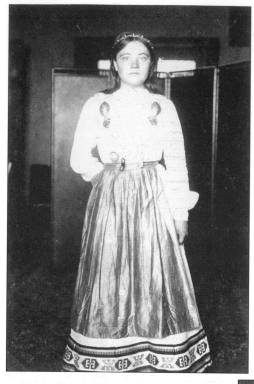

FROM THE GRAND DUCHY OF FINLAND.
Photographed standing before one of the medical examination screens, this girl wears a lovely ensemble distinctive of her native Finland (*Suomi*, in Finnish). Her calm and elegant pose indicates self-confidence. (Augustus Sherman photograph, National Park Service.)

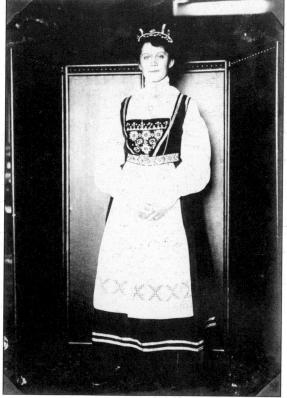

THE SWEDE BEFORE THE SCREEN. This Swedish girl stands in quiet dignity in front of one of the screens that were used to ensure privacy during medical examinations. The purpose of such an enclosure in the case of photography was clearly dictated by the need of solitude and peace—something rather hard to come by in so bustling and crowded an institution as Ellis Island. This girl's outfit is beautifully embroidered, and it is set out, from foot to crown, in a manner decidedly pleasing to the eye. (Augustus Sherman photograph, National Park Service.)

Seven

YOUNG GREENHORNS

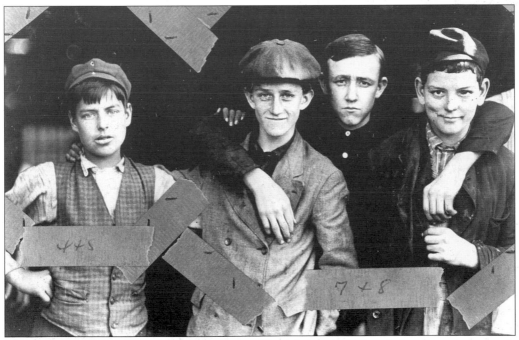

FOREIGN-BORN BOYS WORKING IN AMERICA. These lads quickly found that there was no such thing as "easy money" in America. They joined hordes of other immigrants in the struggle for work. Americans called those who had just left Ellis Island "greenhorns," a term meaning that they did not yet know how to maneuver in American society and would be vulnerable to exploitation, trickery, and deceit. One safeguard was to learn English as soon as possible. (National Park Service.)

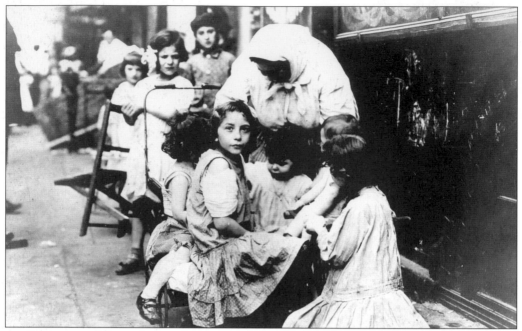

AN IMMIGRANT MOTHER AND GIRLS. Many girls usually worked at home with their mothers, grandmothers, aunts, and sisters. However, a growing number were sent to work in factories and mills and as maids in private households and hotels. Because most of them worked with and remained in the company of other female immigrants from the old country most of the time, girls were usually slower than boys in learning to speak English. For to them, the need to know English was not quite so pressing.

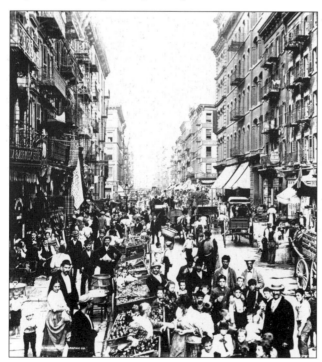

LITTLE ITALY. This photograph of Mulberry Street, in the Lower East Side of Manhattan, was in 1900. It shows the vast extent to which Italian immigration had made the street into what was then the heart of Little Italy. But not all Italians remained in New York. Many went to other North American cities, founding Little Italies in Philadelphia, Boston, Chicago, Newark, Buffalo, Cleveland, Montreal, New Orleans, St. Louis, San Francisco, Los Angeles, and San Diego, among others. (Jacob Riis photograph, Museum of the City of New York.)

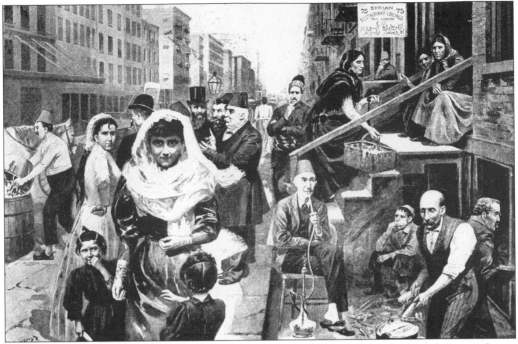

THE SYRIAN QUARTER. Located in Manhattan's Lower West Side around Washington Street (an area later occupied by the World Trade Center), the Syrian Quarter formed the heart of Arab New York. The immigrants were nearly all Christian from the western part of Syria, a region that later became the independent nation of Lebanon. Notable immigrants included Kahlil Gibran and Philip Hitti. Lebanese immigrants also settled in Boston, Detroit, and Los Angeles. (National Park Service.)

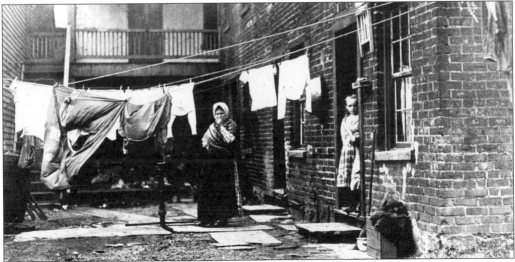

TENEMENT LIFE. Most newcomers to America lived in big cities like New York or Chicago and made their homes in cheap, run-down tenement houses such as the one pictured here. Some were cold-water flats, and the lodgers usually shared toilets with their neighbors. Conditions were unsanitary and excessively crowded. As can be imagined, greedy landlords took advantage of the poor—especially foreigners. (National Park Service.)

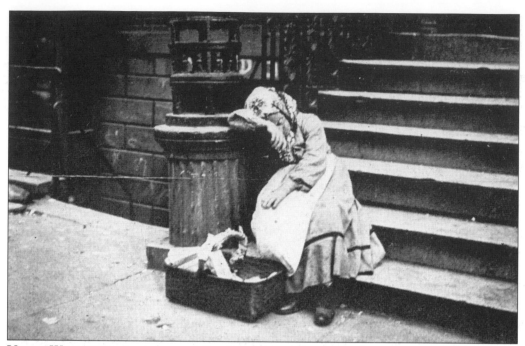

UTTER WEARINESS. An exhausted Czech immigrant slumps on the steps in New York's Lower East Side after a hard day's work. In those days, Czechs were usually called Bohemians or Moravians, depending on which of the two Czech-speaking regions of Austria-Hungary they had come from. (Lewis Hine photograph, author's collection.)

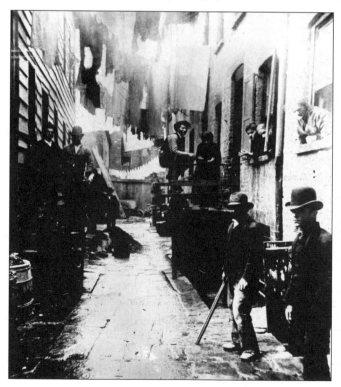

BANDIT'S ROOST. The photographer, a Danish immigrant himself, captures on film these thugs and their neighbors at 39½ Mulberry Street, in the Lower East Side of Manhattan. A variety of poor immigrants lived in this section of New York throughout the years. Such groups included Germans, Irish, Italians, and Jews. (Jacob Riis photograph, Museum of the City of New York.)

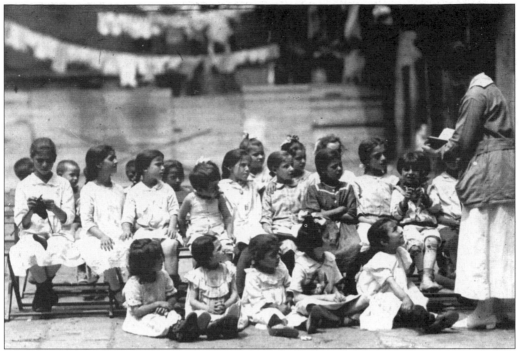

IMMIGRANT CHILDREN WITH THEIR TEACHER. Some classes were conducted outside in summertime. During recess, children could play for a while—but usually under the supervision of a teacher. (National Park Service/NYPD collection.)

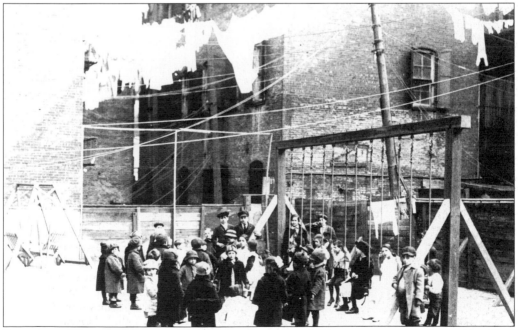

RECESS IN WINTER. In the middle of the school day, children were given a short time to go outdoors and exercise. Called recess, this playing time was embedded in the daily schedule of pupils. (National Park Service/NYPD collection.)

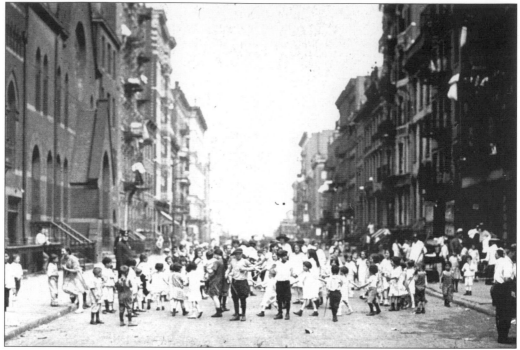

SUMMERTIME. Few immigrant children in New York had parks to go to. Most of them played in the streets with other poor children. Because of the lack of amenities, settlement houses, churches, synagogues, and other organizations offered outings, games, and activities for young immigrants to participate in. At these places, they went on trips, learned games and skills, and were taught American and European cultural traditions. (National Park Service/NYPD collection.)

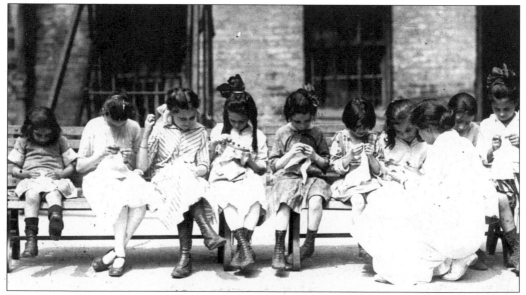

NEW YORK KNITTERS. The girls are engaged in an activity that was traditionally assigned to their gender. Schools, settlement houses, churches, and girls' clubs all encouraged this creative activity. (National Park Service/NYPD collection.)

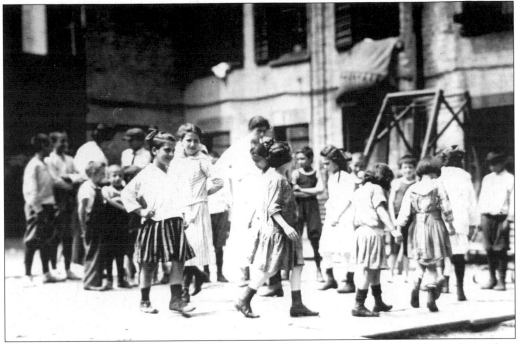

WITH THE DANCING MISTRESS. These schoolgirls are learning a group dance from their schoolmistress. This sort of activity was considered both good exercise and an excellent means of teaching youngsters proper manners in a social environment. Furthermore, group dancing engaged even shy pupils. Girls also played games like London Bridge and attended cooking classes, while both boys and girls studied reading, writing, mathematics, art, history, and geography. (National Park Service/NYPD collection.)

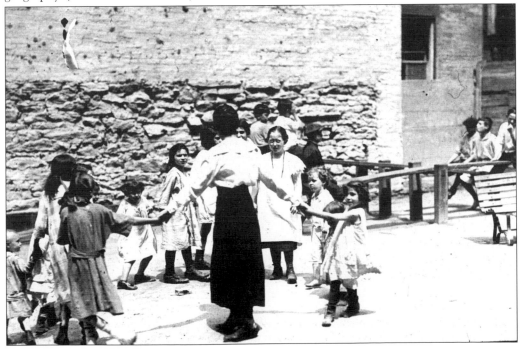

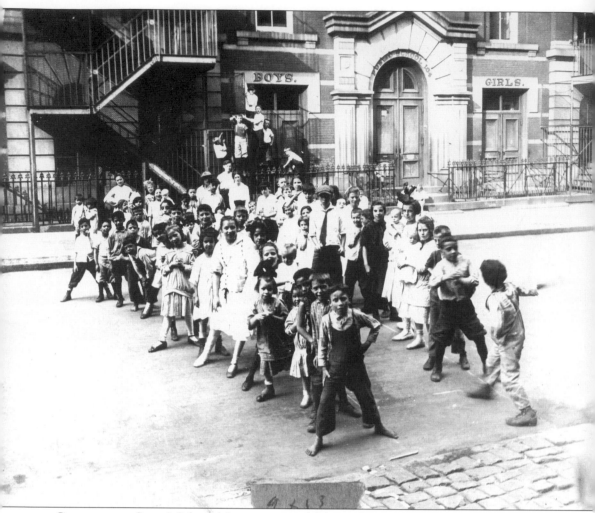

GREENHORNS STILL? School life was a powerful force that put pressure on foreign students to adopt or, at least, learn American ways. This class photograph of some of the schoolchildren of New York's Public School 104 with their teachers was taken in the 1920s. Some of the girls are holding babies—probably younger brothers and sisters they had to take care of. In a crowded city of immigrants like New York, this group might have included a mix of Irish, Germans, Poles, Italians, Jews, Spaniards, Greeks, and Scandinavians. Such a mix of nationalities reduced ethnic isolation and weakened Old World ways. (National Park Service/NYPD collection.)

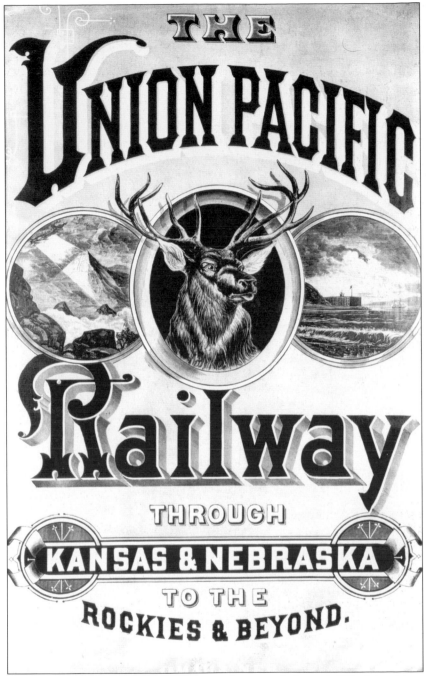

THE WAY WEST. The majority of immigrants who passed through Ellis Island immediately left New York for other destinations. Many bought their train or steamboat tickets in the Railroad Room at Ellis Island. One of the biggest railroad companies selling tickets there was the famous Union Pacific Railway. This line could take passengers from New York and New Jersey all the way to the West Coast. Here is one of the company's many enticing posters that attracted so many people "through Kansas & Nebraska, to the Rockies & Beyond." (Union Pacific Railroad Company.)

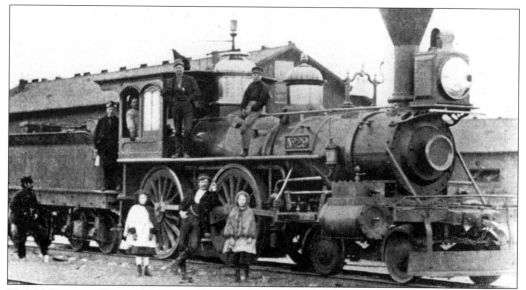

A "SPECIAL EMIGRANT TICKET." Not surprisingly, New York and Chicago were the hubs of transportation in the country. After landing at Ellis Island, a multitude of immigrants went straight to Chicago, where they changed trains for other points. The Chicago, Rock Island and Pacific Railroad Company issued this "Special Emigrant Ticket" good in "emigrant cars only." The immigrant passenger boarded at Chicago's Union Junction on a Central Pacific train bound for San Francisco. Many railroad lines offered these special fares. (National Park Service.)

UNION PACIFIC. Pictured here is a quite typical sort of train that was once seen all over the country. Railways unified the nation, for they were the primary way to travel before airlines became dominant in the 1960s. Trains also were the domestic primary carriers of goods and cargo before the rise of the trucking industry. Beside Union Pacific, other major railway lines included the New York Central, the Pennsylvania Railroad, the Baltimore & Ohio, the Burlington Line, Northern Pacific, Canadian Pacific, and the Santa Fe Railway. (Union Pacific Railroad Company.)

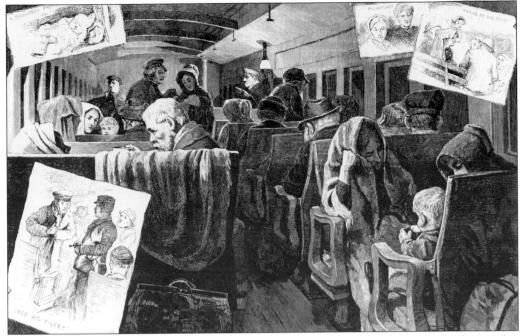

ON AN IMMIGRANT TRAIN, WESTWARD BOUND. Drawn by artist G. S. McCutcheon, this picture gives a warm feeling of a sleepy group of immigrants on their way to their new homes in America. The four miniature insets highlight the experience: a sleeping baby, without care or troubles, is labeled a "Privileged Passenger" (upper left); an immigrant faces a dramatic moment in "Lost His Ticket" (lower left); an Alsatian man and woman look ahead to their future, while passengers are "Waiting at the Depot" (both upper right). (National Park Service.)

THE RAILROAD "EMIGRANT HOME." In the late 19th century, some railroad companies built comfortable lodging houses for immigrant families to stay in on their way to towns or farms. These lodgings answered the fear many had about the immediate discomfort awaiting them when they arrived in the wilderness. The sketch shows the Burlington and Missouri Railroad Emigrant Home in Lincoln, Nebraska, the first such home to be set up as a reception house to give shelter, lodging rooms, and provide appliances for cooking to all strangers without charge. (National Park Service, Burlington Lines.)

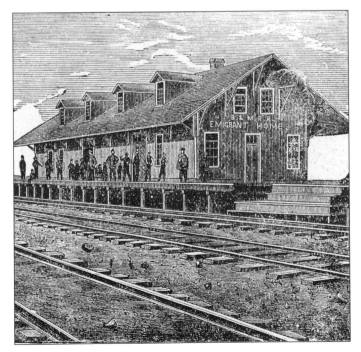

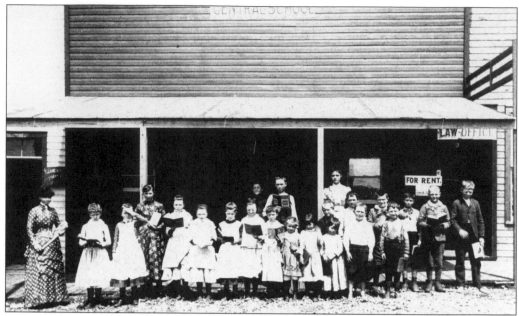

A COUNTRY SCHOOL. This was the typical sort of school to be found in small communities in the western states and territories from the 1870s through the 1920s. (National Park Service.)

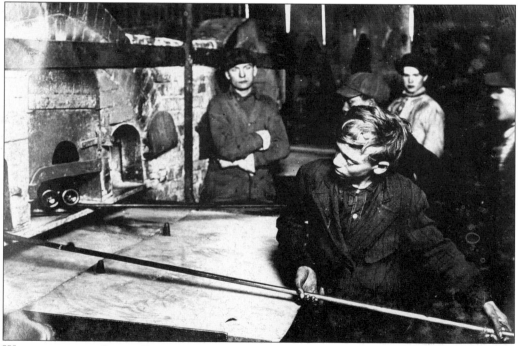

WORKING IN A GLASS FACTORY. Jobs in places like glassworks were readily available to boys and men. This kind of work was hard and could be dangerous. Yet thousands of young immigrants sought such jobs because they learned to make a product that was always wanted. (National Park Service.)

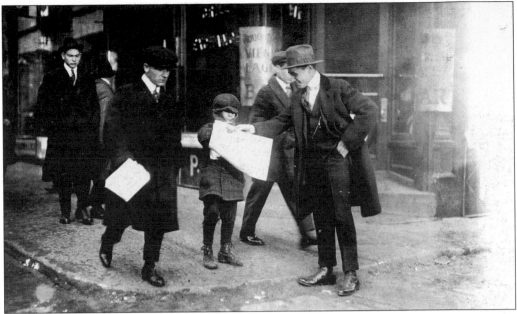

A Boston Newsboy. An underage newsboy sells newspapers to his customers at 5:00 in the afternoon on January 27, 1917. Many of the Boston's newsboys were Irish born. (Lewis Hine photograph, National Park Service.)

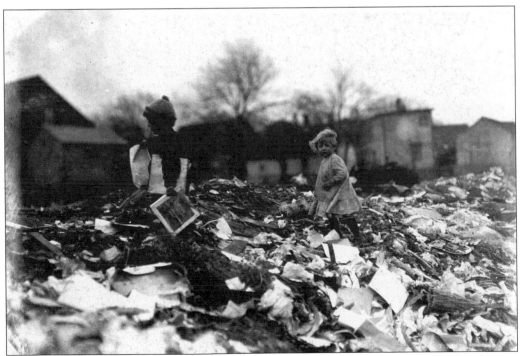

Going through the Dumps. Passing through the "dumps," either homeward bound or on some errand, was an everyday experience for some immigrants. As can be seen here, dumps were open areas where a town or city's refuse, rubbish, and castoffs were tossed. This picture was taken for the National Child Labor Committee. (Lewis Hine photograph, Library of Congress.)

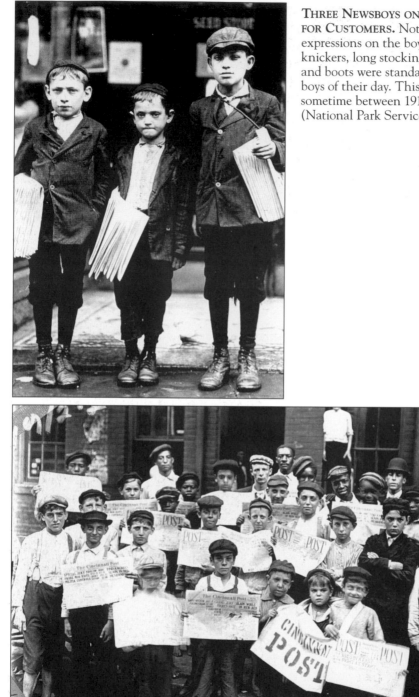

THREE NEWSBOYS ON THE WATCH FOR CUSTOMERS. Note the serious expressions on the boys' faces. Coats, knickers, long stockings, cloth caps, and boots were standard dress for city boys of their day. This picture was taken sometime between 1910 and the 1920s. (National Park Service.)

SALES BOYS OF THE CINCINNATI POST. This racially mixed group of lads gave their all to find buyers for the *Cincinnati Post*. All over the country, papers were distributed by newsboys, many of whom were foreign-born. Aside from the major newspapers, some boys worked for the foreign language presses as well. (National Park Service.)

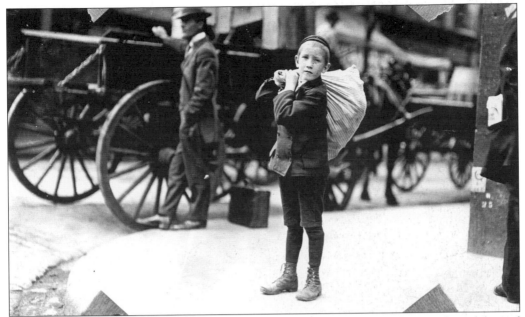

BOY PEDDLER? This boy has quite a sackful of something to sell on his back. Some boys delivered groceries, bread, and meat, while others peddled goods in the streets. They peddled items like matchsticks, shoelaces, scarves, lemonade, or fruit. Girls often sold real or artificial flowers, candies, or ribbons. (National Park Service.)

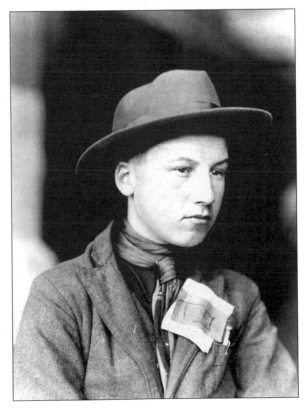

THE STYLE OF BYGONE DAYS. This was the way many older boys dressed in the days of mass migration. By the look of the fountain pen in his pocket, it is likely be that this boy attended school or, at least, may have worked at a job that required him to do some writing. (National Park Service.)

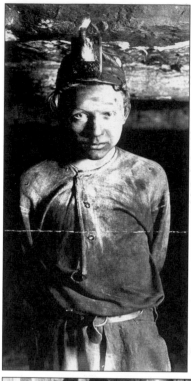

A Boy from the Coal Pits. Many boys worked down in the pits of coal mines as water boys and helpers. German, Slovak, Pole, and Welsh immigrants were commonly found doing this kind of dirty work. (National Park Service.)

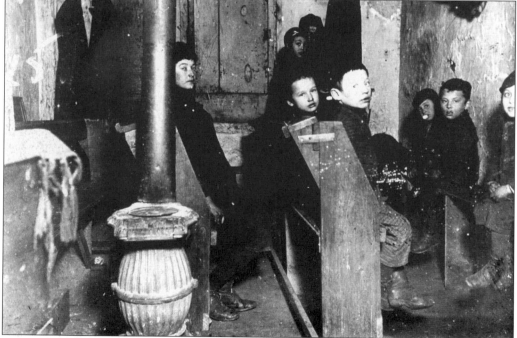

Cold Comfort. These lads are sitting on benches in a decidedly inferior establishment. As can be seen on the left, heating is provided by what appears to be a coal stove. This way of life was commonplace in America during the 19th century and first half of the 20th century. (National Park Service.)

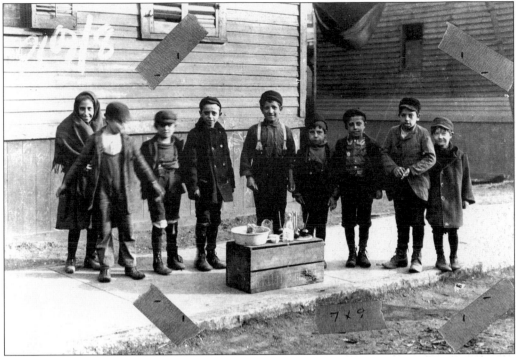

SELLING REFRESHMENTS. These poor youngsters from abroad had to learn the art of trade and commerce at quite an early age, since many lived in very real poverty. The money they earned usually went into the household budget to keep the wolf away from their door. (National Park Service.)

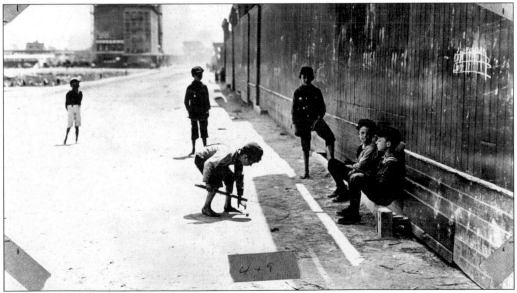

HOT AND DUSTY. Here six poor boys relax on a hot and dusty day. Immigrant kids often created their own outdoor amusements and games. Among other things, they might follow the railway tracks just to explore the world beyond their often dreary neighborhoods. (National Park Service.)

FANCY DRESS DAYS. On special occasions such as this one, immigrant mothers dressed their children up in fine outfits. As seen here, the clothing worn on special days was of the sort that they would likely have worn in their ancestral village in Europe. This girl seems quite satisfied wearing her traditional European clothes, as is her mother, who watches her children in an appraising manner. Note that the son is dressed in an American or western European suit. (National Park Service.)

NO FASHION PLATES, THEY. These two brothers are obviously none too pleased to be photographed. They might have been rural boys who lived on a farm. Such a life was appealing to those who preferred agricultural pursuits in a rural setting to the haste of town life. (National Park Service.)

Eight

THE LEGACY
OF ELLIS ISLAND

ISLAND OF ENEMY ALIENS. By the time this picture was taken in 1950, mass immigration was over and most of the children who had passed through the station in earlier years had grown up. Of course, Ellis Island did not close for many years yet and children were still to be found there, but now exclusively as detainees. In 1941, the children of world famous pianist Arthur Rubenstein were detained there for chicken pox, and during World War II, hundreds of children of immigrants accused of being enemy aliens found themselves at Ellis Island. Their parents were accused of being Nazis, Fascists, or spies. Although many of these youngsters were American citizens, they still had to stay in detention with their parents; and if the parents were deported, the children went with them into exile. There were also many Asian children at Ellis Island; most were Chinese, Japanese, or Korean. Pres. Dwight D. Eisenhower closed Ellis Island on November 12, 1954. (National Park Service, Immigration and Naturalization Service.)

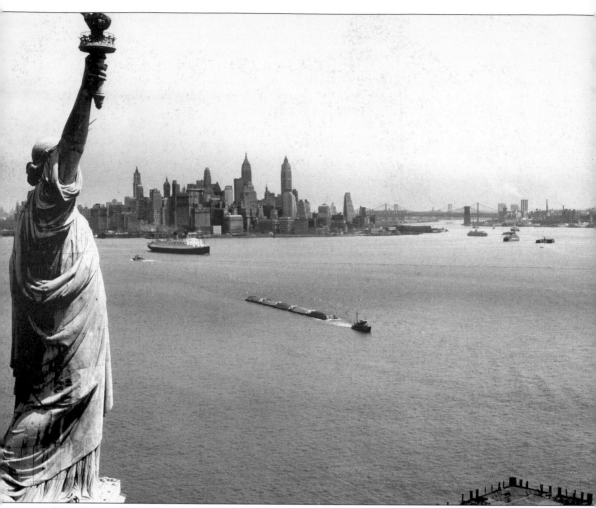

NEW YORK HARBOR IN 1956. After Ellis Island closed in 1954, the government decided to sell the island. However, many immigrants who had passed through Ellis Island as children years before joined with others in opposing the sale. They argued that the island had served as the gateway to America for millions of immigrants seeking freedom, opportunity, and happiness. They cited that most of the immigrants had contributed richly to America's culture and prosperity through their labor, ingenuity, loyalty, talents, and creativity. These arguments finally persuaded Pres. Lyndon B. Johnson to declare Ellis Island a part of the Statue of Liberty National Monument on May 11, 1965. (National Park Service, Port of New York Authority.)

HOLLYWOOD EYES IMMIGRATION. English actor Charlie Chaplin starred in the silent film classic *The Immigrant* in 1917. His leading lady was Edna Purviance. Portraying emigrants from Europe, they highlighted the misery of traveling in steerage and the difficulty of passing through Ellis Island. Ironically, only two years after the film came out, Charlie Chaplin's own mother was detained at Ellis Island. She had failed the mental tests, and doctors duly certified her as mentally deficient and feebleminded. This caused an uproar, and she was released only after her son posted a bond guaranteeing that she would not become a public charge. Aside from Chaplin's classic film, other movies made about Ellis Island include *The Immigrant* (1915) with Valeska Suratt, *My Boy* (1921) with Jackie Coogan, *Ellis Island* (1936) with Donald Cook, and *Gateway* (1938) with Don Ameche. (National Park Service.)

ANNIE MOORE AND HER BABY. When she arrived in America in 1892, 15-year-old Annie Moore was the first immigrant to pass through Ellis Island. Her younger brothers Anthony and Philip were the second and third. This picture was taken of her years later when she was married to Patrick O'Connell. She is holding their baby daughter, Mary Catherine O'Connell. At Ellis Island, she was presented with a $10 gold coin from the superintendent of the station, Colonel Weber; she also received a blessing from Rev. Fr. Michael Henry, the Irish missionary priest. The children's parents were there to take Annie and her brothers to their home in a tenement building in New York's Lower East Side. (National Park Service.)

Norwegian American Patriots during World War I. As young adults, hundreds of thousands of immigrants who had passed through Ellis Island as boys fought in the armed forces during both world wars. By joining the military, they were rewarded by being swiftly granted U.S. citizenship. Although not in uniform, even civilians of foreign birth often went out of their way to prove their patriotism. Here the Sons of Norway, a fraternal association, sponsored an ethnic parade that emphasized loyalty to the United States. America's chief foes during this war were Germany and Austria-Hungary, and, as a result of this, countless numbers of German and Austrian immigrants were treated with hostility and suspicion and were commonly harassed and even assaulted. To protect themselves, many men shaved off their Teutonic-style ("Kaiser Bill") moustaches, and some people even anglicized the spelling of their last name. (National Park Service.)

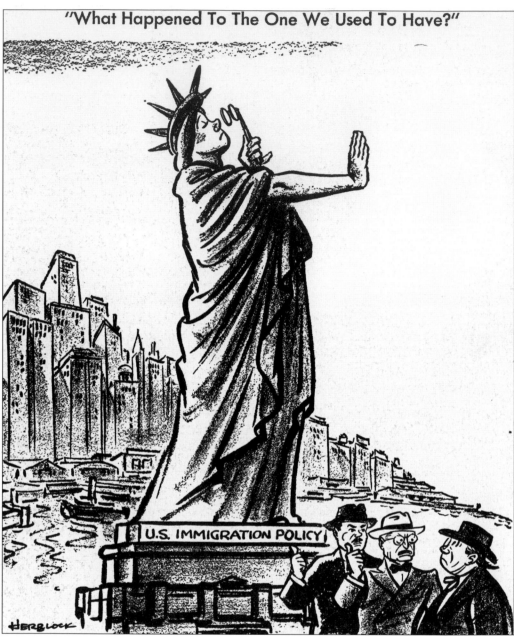

"What Happened To The One We Used To Have?"

KEEPING IMMIGRANTS OUT. America's tough immigration restriction law of 1924 remained in force for 41 years. To many, the effect this law had on the lives of people made it seem a cruel one. This was especially true in the 1930s and 1940s, when thousands of refugees fled the torments of Nazi Germany, as well as the wars in China and Europe. This 1946 cartoon features Pres. Harry Truman questioning why American liberty is no longer available to immigrants. Although the law was not changed, Congress finally agreed to make an exemption that let in "displaced persons" (refugees) and war brides. The restrictive Immigration Act of 1924 was replaced in 1965 by a more liberal law. (Herblock cartoon, the *Washington Post*.)

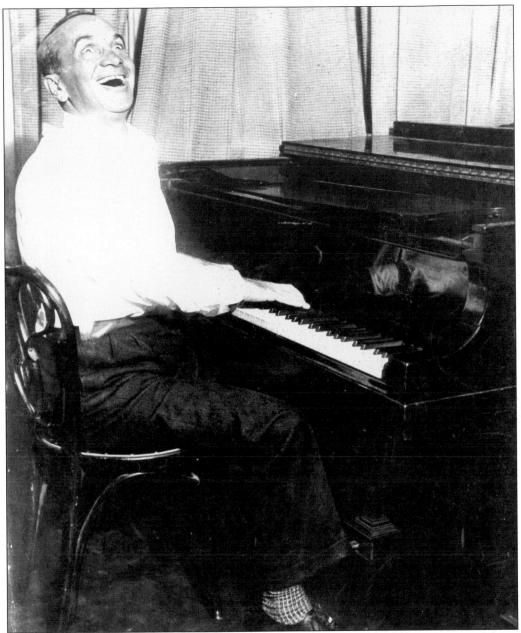

AL JOLSON, VAUDEVILLIAN. A Lithuanian Jew, Al Jolson (1886–1950) arrived at Ellis Island in 1894 at the age of eight. He grew up in Washington, D. C., and became one of America's most popular entertainers. He was the first Jew to become a major national celebrity. He had a long career in show business and won acclaim in vaudeville, in Broadway musical comedies, records, motion pictures, and in his radio broadcasts. In addition, he was the first actor to star in a talking picture; the film was *The Jazz Singer* (1927). In this production, he showcased his singing, which had long endeared him to the fans of his vaudeville and Broadway shows. Like many immigrants of his generation, he was ashamed of having being been foreign-born and often claimed that his birthplace was Washington, D. C., not Russia. He died playing a game of gin rummy in a hotel in San Francisco. (National Park Service.)

ANZIA YEZIERSKA, NOVELIST. In the early 1920s, American letters received a powerful contribution from immigrant writer Anzia Yezierska (1885–1970). A native of Russian Poland, Anzia Yezierska emigrated to New York with her family around 1894. They settled in the Lower East Side. Struggling to rise out of poverty and ignorance, she became a domestic science teacher and taught cooking from 1905 to 1913. Her powerful literary works depicted the struggle for assimilation and betterment by Jewish women seeking to free themselves from the heavy hand of Old World tradition. In 1920, her first volume appeared. This book of 10 short stories was called *Hungry Hearts*. It caused quite a sensation when it appeared, and producer Samuel Goldwyn made it into a successful motion picture. Her novels include *Salome of the Tenements*, *Children of Loneliness*, *Bread Givers*, and *Arrogant Beggar*. She died in poverty. (Author's collection.)

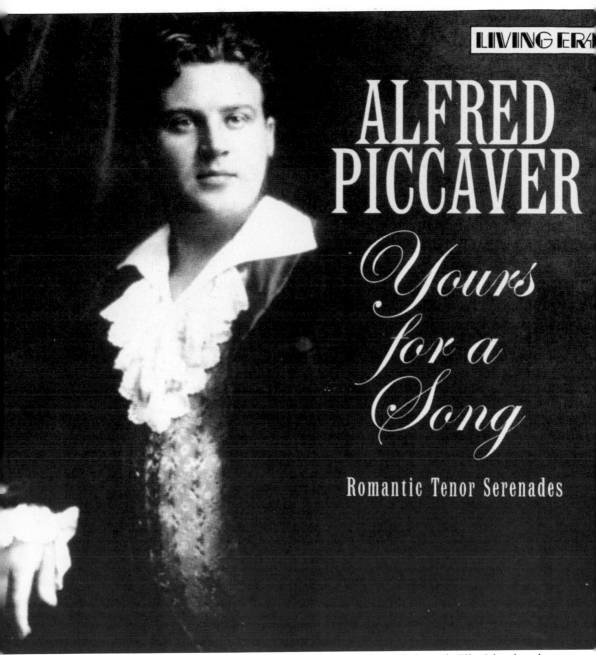

ALFRED PICCAVER

Yours for a Song

Romantic Tenor Serenades

ALFRED PICCAVER, OPERA SINGER. This English immigrant passed through Ellis Island with his family in 1894 at the age of 10. The Piccavers left their farm life in Lincolnshire, England, for Albany, New York. Wanting to become a singer, Alfred Piccaver (1884–1958) came to New York City around 1902 at age 18. In 1905, he won a scholarship to the Metropolitan Opera School. He survived by working as an electrical engineer at Thomas Edison's laboratories at Orange. In 1907, Piccaver made his début at the Deutsches Theater in Manhattan and, on a bursary, sailed four days later to continue his studies in Europe. From 1912 onward, his fine singing voice earned him international acclaim as one of opera's greatest stars. In fact, his voice was often compared to Enrico Caruso's. Piccaver died in Vienna, Austria. (Author's collection.)

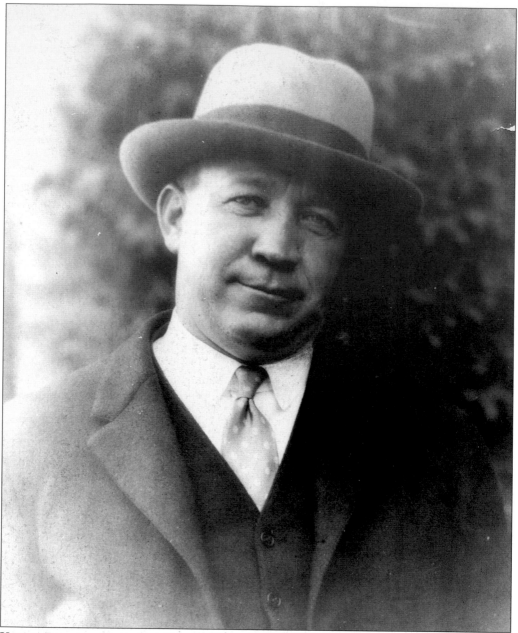

KNUTE ROCKNE, FOOTBALL COACH. Knute Rockne was only five years old when he passed through Ellis Island in 1893. His mother was taking him to join his father, Lars Rockne, who was putting the finishing touches on a carriage to be exhibited at the Chicago World's Fair. Young Rockne grew up in Chicago and studied chemistry at Indiana's University of Notre Dame, eventually becoming a teacher there. University officials noticed his genius for coaching football, and they turned the college team over to him. The rest is history, for Rockne made Notre Dame's Fighting Irish America's greatest college football team. Even after his untimely death in 1931, Knute Rockne remained a national hero. In 1940, Ronald Reagan and Pat O'Brien starred in a biopic drama about the football coach, the movie classic *Knute Rockne, All-American*. (University of Notre Dame.)

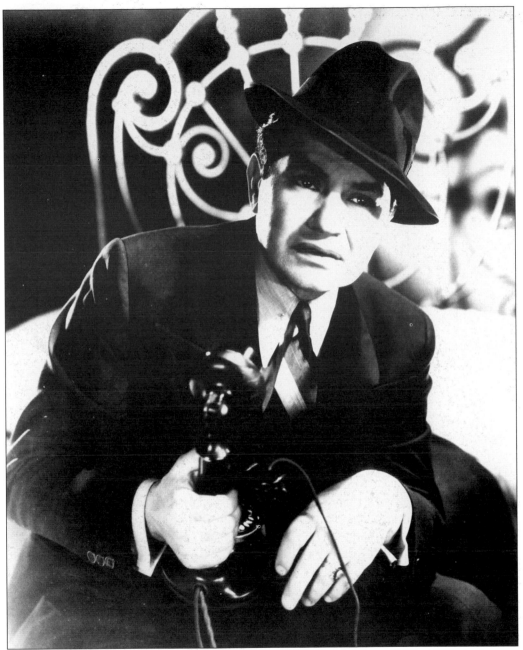

EDWARD G. ROBINSON, ACTOR. Screen legend Edward G. Robinson (1893–1973) was a poor Jewish boy when he arrived at Ellis Island as Emanuel Goldenberg in 1903. The actor later reminisced about the wretchedness of life for Jews in Romania and his family's emigration. He declared, "At Ellis Island I was born again. Life began for me when I was ten years old." He grew up in New York and fell in love with the theater, where he learned to improve his broken English. He saw a play that featured a character called Edward G. Robinson. Liking this English name, he adopted it for himself and became a professional stage actor. His powerful acting style led to theatrical success, and this, in turn, led him to stardom in Hollywood. His screen credits include *Little Caesar*, *Scarlet Street*, *Double Indemnity*, and *Key Largo*. (National Park Service.)

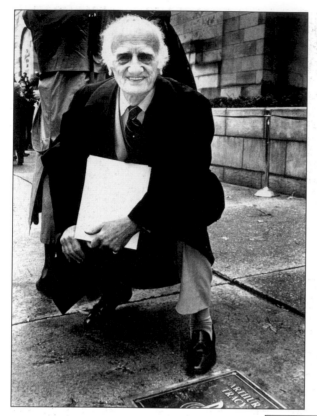

ARTHUR TRACY, THE STREET SINGER. In 1906, seven-year-old Abba Tracovutsky (1899–1997) fled from Russia. From Ellis Island, the family moved to Philadelphia, where the boy fell in love with singing. In 1917, he became a vaudeville singer and, by 1931, he had won stardom in radio and records as Arthur Tracy, "the Street Singer." Fame led to movie roles in *The Big Broadcast*, *The Street Singer*, and *Follow Your Star*. He is shown in Philadelphia, inspecting his name on the Walk of Fame. Interestingly, his famous theme song, "Marta," was written by L. Wolfe Gilbert, who also came from Russia and grew up in Philadelphia. (National Park Service.)

FRANK CAPRA AND CLAUDETTE COLBERT. Movie legends Frank Capra (1897–1991) and Claudette Colbert (1903–1993) both immigrated through Ellis Island as children. Capra, an Italian, was six (1903) and Colbert, a French girl, was three (1906). Capra was one of Hollywood's leading film directors, and Colbert became one of its greatest stars. They are shown here with Clark Gable (right), discussing their film *It Happened One Night* (1934). (National Park Service.)

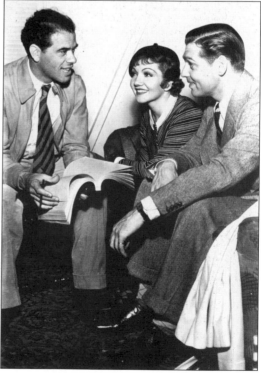

MAYOR ABRAHAM BEAME.
A Polish Jew, Abraham
Beame came to America from
England in 1906, when he
was only a baby. He became a
schoolteacher but eventually left
education for politics. He served
as mayor of New York City
from 1973 to 1977. He is seen
here on a visit to Ellis Island
with his wife, Mary Beame, in
1993. (Kevin Daley photograph,
National Park Service.)

COMMISSIONER EDWARD CORSI. Italian-born Edward Corsi (1896–1965) immigrated through
Ellis Island when he was 11 and settled in New York with his family. He became a lawyer but
made a name for himself as a social worker. This led to Pres. Herbert Hoover's appointing him
commissioner of Ellis Island (1931–1935). Corsi is pictured in 1956, serving as an executive for
the American Museum of Immigration project. (The *New York Times*.)

BOB HOPE, COMEDIAN. Passing through Ellis Island as Leslie Hope at the age of five in 1908, English-born Bob Hope (1903–2003) eventually became one of America's most popular comedians. Making his start in vaudeville, he achieved fame on Broadway, in movies, and on radio and television. His many films include *The Big Broadcast of 1938*, *The Cat and the Canary*, and *Beau James*. He is seen here signing autographs for American soldiers in World War II. (National Park Service.)

EMMIE KREMER, POET. German immigrant Emmie Kremer was processed at Ellis Island when she was seven years old in 1926. Her father was a brewer, and the family settled in Brooklyn. She went on to become a mother and housewife. She now writes poetry, and her *Song of Ellis Island* is on exhibition in the reading room of the Ellis Island Immigration Museum. She is pictured at the Elmont Public Library in Queens. (National Park Service.)

ISABEL BELARSKY. Russian immigrant Isabel Belarsky was 10 years old when she posed with her favorite doll for this April 1930 photograph. She had only been in America for two months, having been released from Ellis Island in February. (National Park Service, Isabel Belarksy Collection.)

ISABEL BELARSKY WITH HER FATHER, SIDOR BELARSKY. Sidor Belarsky (1898–1975) was a distinguished opera singer when he arrived for a theatrical engagement in February 1930. Since he and his family were from the Soviet Union, they were automatically detained at Ellis Island, as the United States had no diplomatic relations with their country. The Belarskys were released on February 8. Belarsky was also an outstanding singer of Yiddish folk songs. This picture was taken in 1931. (National Park Service, Isabel Belarksy Collection.)

ISABEL BELARSKY TODAY. Isabel Belarsky is pictured here with her samovar, a treasured appliance for making tea, which was brought from Russia through Ellis Island. Over the years, she has generously shared her family history and her own story and that of her father, gifted singer Sidor Belarsky. Her interview can be heard in the Ellis Island Oral History Listening Room. Additionally, Sidor Belarsky's extraordinary voice can still be heard on his records, CDs, and cassette tapes. (National Park Service, Isabel Belarsky Collection.)

ST. BRIGID'S, THE HISTORIC IRISH FAMINE CHURCH. This citadel of Irish heritage was built to serve the countless thousands who fled the terrible potato famine in 19th-century Ireland. Immigrant architect Patrick Keely designed it in 1848, and it served the Irish Diaspora for decades. Even Annie Moore's family lived in the parish and almost certainly worshipped here. Inexplicably, the Archdiocese of New York plans to demolish it. Ellis Island park ranger Dave McCutcheon made this painting of it in June 2005. (Dave McCutcheon painting, National Park Service.)

UNVEILING THE STATUE OF ANNIE MOORE AT ELLIS ISLAND. To pay tribute to the first immigrant who was also the first child to pass through Ellis Island, this statue of Annie was unveiled in May 1993 by Irish president Mary Robinson. (National Park Service.)

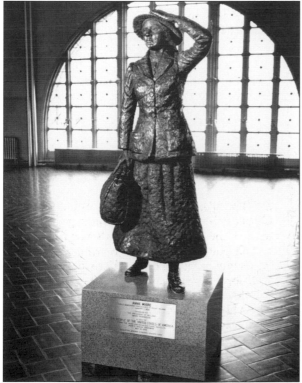

ANNIE MOORE IN THE GREAT HALL. This statue of the young Irish lass stands in the Registry Room (Great Hall) at the Ellis Island Immigration Museum. It has since been moved to the East Wing, which is close by. Irish sculptress Jeanne Rhynhart designed this statue, as well as its companion, which stands in Cobh, Ireland. The Cobh statue includes sculptures of Annie's brothers, Anthony and Philip Moore. (Kevin Daley photograph, National Park Service.)

KAHLIL GIBRAN, POET.
Kahlil Gibran (1883–1931) left Lebanon with his family in 1895. After passing through Ellis Island, the family settled in Boston. On the left is a photograph that was taken of the 13-year-old Arab immigrant in 1896. He gained distinction as a poet and painter. His mystical, philosophical vision shines forth in *The Prophet*. (Author's collection.)

GRAFFITI. Throughout Ellis Island, detained aliens left behind testaments of their frustrations and disappointment in the form of graffiti. Although some are drawings and sketches, most are writings. Christy Cunningham of the National Park Service conserved these inscriptions in the 1980s. Thanks to this, a number of them are now on display. However, those pictured here remain unseen, for they are in the Baggage and Dormitory Building, which is off-limits to the public. (National Park Service.)

Appendix
Statistics of Child Immigration

Between 1892 and 1954, approximately 3.4 million children immigrated to the United States.

Year	Number of Children	Year	Number of Children
1892	89,167	1924	132,264
1893	57,392	1925	50,722
1894	41,755	1926	47,347
1895	33,289	1927	51,689
1896	52,741	1928	49,680
1897	38,627	1929	47,935
1898	38,267	1930	40,777
1899	43,983	1931	17,320
1900	54,624	1932	6,781
1901	62,562	1933	4,131
1902	74,063	1934	5,389
1903	102,431	1935	6,893
1904	109,150	1936	6,925
1905	114,668	1937	8,326
1906	136,273	1938	10,181
1907	138,344	1939	12,204
1908	112,148	1940	9,602
1909	88,393	1941	7,982
1910	120,509	1942	3,710
1911	117,837	1943	3,179
1912	113,700	1944	4,092
1913	147,158	1945	5,645
1914	158,621	1946	11,092
1915	52,982	1947	18,831
1916	47,070	1948	24,095
1917	47,467	1949	32,728
1918	21,349	1950	50,468
1919	26,373	1951	44,023
1920	81,890	1952	64,513
1921	146,613	1953	37,016
1922	63,710	1954	45,105
1923	91,816		

BIBLIOGRAPHY

Adamic, Louis. *Laughing in the Jungle: The Autobiography of an Immigrant in America*. New York: Harper & Brothers, 1932.

Corsi, Edward. *In the Shadow of Liberty: The Chronicle of Ellis Island*. New York: Macmillan, 1935.

Freedman, Russell. *Immigrant Kids*. New York: E. P. Dutton, 1980.

Haroutunian, Virginia. *Orphan in the Sand*. Bloomfield Hills, Mich.: [privately published], 1995.

Lawlor, Veronica. *I Was Dreaming to Come to America*. New York: Viking, 1995.

Mesenhöller, Peter. *Augustus F. Sherman: Ellis Island Portraits, 1905–1920*. New York: Aperture Foundation, 2005.

Moreno, Barry. *Encyclopedia of Ellis Island*. Westport, Connecticut: Greenwood Press, 2004

Novotny, Ann. *Strangers at the Door: Ellis Island, Castle Garden and the Great Migration to America*. Riverside, Connecticut: the Chatham Press, 1971.

Papashvily, George. *Anything Can Happen*. New York: Harper & Sons, 1945.

Pitkin, Thomas. *Keepers of the Gate*. New York: New York University Press, 1975.

Riis, Jacob. *How the Other Half Lives*. New York: Charles Scribner's Sons, 1901.

Sandler, Martin W. *Island of Hope: The Story of Ellis Island and the Journey to America*. New York: Scholastic, 2004.

Severn, Bill. *Ellis Island: The Immigrant Years*. New York: Julian Messner, 1971.

Smith, Eugene W. *Passenger Ships of the World - Past and Present*. Boston: George H. Dean Company, 1963.

Yezierska, Anzia. *Children of Loneliness: The Story of Immigrant Life in America*. New York: Funk & Wagnalls, 1923.

INDEX